*Edmund de Waal*

# Bernard Leach

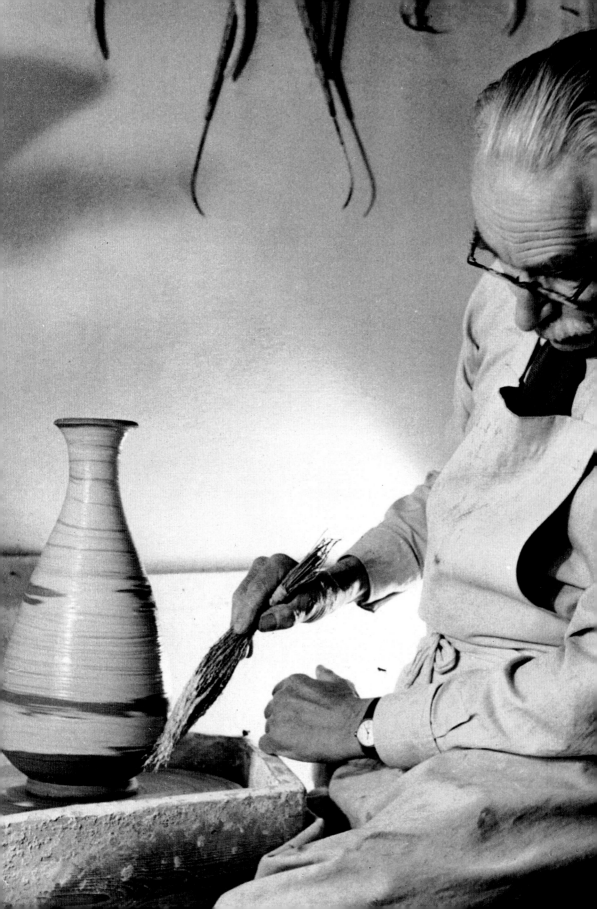

# Bernard Leach

Edmund de Waal

ST IVES ARTISTS

Tate Gallery Publishing

cover:
'Tree of Life' Vase *c.*1956 (fig.52)

frontispiece:
Bernard Leach in 1965 appyling 'hakeme'
decoration to a vase

ISBN 1 85437 227 0

A catalogue record for this book is available
from the British Library

Published by order of the Trustees of the
Tate Gallery by Tate Gallery Publishing Ltd,
Millbank, London SW1P 4RG

Cover designed by Slatter-Anderson, London
Book designed by Isambard Thomas

Printed in Hong Kong by South Seas
International Press Ltd

Measurements are given in centimetres, height
before width

St Ives Artists
The light and landscape of West Cornwall
have made it a centre of artistic activity for
over one hundred years. This series
introduces the life and work of twentieth-
century artists, of national and international
reputation, who have been closely associated
with the area, and whose work can be seen at
Tate Gallery St Ives.

Acknowledgements
The research for this book was aided by
a scholarship from the Daiwa Anglo-Japanese
Foundation. A particular debt of gratitude is
owed to Dr Sori Yanagi and Teiko Utsumi of
the Mingei Kan, Tokyo, for access to the
Yanagi Archives, to Barley Roscoe of the Bath
Craft Studies Centre for access to the Leach
archives, and to the Trustees of the Bath
Crafts Studies Centre for permission to
reproduce material. I am also grateful to the
Crafts Council for their generous contribution
towards new photography. Conversations with
David Leach, the late Janet Leach, Yuko
Kikuchi, Chiaki Ajioka, Oliver Watson,
Emmanuel Cooper, David Whiting, Margot
Coatts and Julian Stair have provided much
help and stimulus. Susan Powell's help has
been invaluable. To Geoffrey Whiting and
Susan Chandler I owe most of all.

# Contents

# Introduction

Bernard Leach was the pre-eminent artist-potter of this century. In both the West and in Japan his influence on the construction and growth of a studio pottery movement has been profound. Through his indefatigable writing and lecturing on the making and meaning of pottery and his tuition of some of the foremost artist-potters, as much as through his actual making of pots, Leach was at the centre of the question of how pots are valued and appreciated critically. He was deeply involved in shaping the canon of historical pottery on which much of current pottery still draws. Leach's knowledge of Oriental pottery and aesthetics, demonstrated in both his pots and books, was instrumental in placing key ideas and images of a meeting of East and West at the heart of the movement. Much of his passionate advocacy, notably in his most significant writing, *A Potter's Book*, centred on the idea of 'appropriateness': on the idea of a kind of propriety that can be found in the choice of the materials that make up a pot, and in the conduct of the potter himself. It was an ethos of 'truth to materials' that was grounded not only in his experiences of Oriental pottery, but also in the contemporary concerns of artists and sculptors who worked around him for a significant period in St Ives. Leach's advocacy for pots that could be used as part of everyday life has entered the mainstream of perceptions about his pottery. How these pots were made, and for whom, reveals his social values as well as his ideas of roles within the organisation of a workshop.

Leach's ideas, as much as his pots, must be seen in the context of the times that shaped them. He was accustomed to using sweeping arguments and value-laden terms when scrutinising the position of potters within society; of talking in general terms of the relationship between East and West. The sources of these arguments and these values are very particular indeed. If we consider the particular make-up of Leach's Japan and Leach's England, the paradoxes at the heart of his creating and thinking become much clearer, and his particular achievements can be better appreciated.

# 1
# Naive Power
## 1887–1920

Bernard Leach was born and brought up in the Far East. Both sides of his family had made their lives there; his father as a colonial barrister in Hong Kong, his maternal grandparents missionaries at the first Christian University in Japan. Leach's mother died soon after he was born and he spent his first four years with his grandparents in Japan before rejoining his father. He was raised in a conventional colonial world and his prospects as a young man were similarly predictable. He was sent back to England at the age of ten to be schooled and prepared for entry into the Hong Kong and Shanghai Bank. This prospect dismayed him intensely and with his growing passion for drawing he prevailed on his father to allow him to study art at the Slade School in London in 1903: 'To me, this was sheer joy. Life began to take on some meaning'.[1]

A key to 'the admirable singularities' of the Slade School of Art in 1903 was that 'students … were not examined on admission … and the tradition was that the teachers should be practising artists'.[2] The Slade was presided over by Henry Tonks: a fine draughtsman, noted in his teaching for his 'voice of inspired scepticism'. Its reputation at that time was for instilling solid academic drawing skills in the students. Leach flourished.

In 1904 faced with the imminent death of his father, Leach felt that there was little choice but to return to a more conventional career. He joined the Hong Kong and Shanghai Bank in 1906 but banking proved 'utterly alien'[3] to him and to the bewilderment of his remaining family he sent himself back to art school after a year. At the London School of Art he encountered the much emulated Augustus John and began a friendship with, amongst others, Henry Lamb. He also met the second of his inspirational teachers, Frank Brangwyn. Brangwyn was at the height of his fame as an etcher, working in the genre on a scale and with an ambition that was unmatched at the time. Brangwyn's work was praised for its 'masculinity' and the vivid way in which it engaged with modern urban living. Leach's first etchings, *Coal Heaver* amongst them, were made under his shadow. These first etchings, though obviously derivative in their mannerisms, show the stirrings of an independent sensibility. Moreover it was Brangwyn who, on hearing that Leach had spent five terms in art schools, was to be emphatic in his advice to leave.

Leach had few ties – he now had neither parents nor siblings. He decided to return to Japan. This decision, he relates, was bound up for him with his romantic experience of living in Chelsea, a place where through the influence of the paintings of James McNeill Whistler, London and Japan met in 'some dream of Japan'.[4] But it was also bound up with his enthusiastic reading of Lafcadio Hearn, the hugely popular sentimental writer on Japanese life and folklore. Hearn's Japan was a world of lavish and exotic detail, and of

numinous happenings and ghostly encounters. Japan was synonymous with the mysterious, with the 'highly refined taste' of a very particular late Victorian milieu. However it also meant, for an ambitious young man, unbounded possibility for as with other men of his class and circumstance 'The East is a career.'[5]

Bernard Leach arrived back in Japan in 1909. He was twenty-two years old and full of idealism, with a boundless self-confidence. He took his etching press with him, intending to establish himself as a painter and to make his living through the teaching of etching. Leach was armed with a small private income of £100 a year and some key introductions. Takamura Kotaro, a close friend from the London School of Art, gave him an introduction to his father, the sculptor for the Imperial Court. Another significant introduction was to Baron Imamura, who taught at the Tokyo School of Art. There were also friends of his grandparents, still well-placed within Tokyo society.

1
*Coal Heavers, Earls Court Road* 1905–1910
Etching
20 × 16.6 cm
National Museum of Wales, Cardiff

Leach launched himself enthusiastically into his new life. He had a house and studio built in the north of Tokyo near the Art Museum and Art School, with sunken flooring to accomodate Westerners' legs unaccustomed to Japanese traditions of kneeling. He started to learn Japanese. Within a month of arriving, in an article entitled *The Introduction of Etching into the Art World of Japan,* published in translation in a Japanese magazine, Leach aired his views on the characteristics of Japanese art: 'not dynamism, but the development of the exquisite decorative concept'. These characteristics were best demonstrated in the use of light and line: 'Therefore I think the technique of etching – etching, basically an art of appreciation of various lines – must be of great interest for young talented artists to learn.'[6] And he was to write 'line was my metier'.[7] He could not have made his ambitions, or his self-confidence, clearer.

Leach's timing was perfect. He had enormous cachet through his connections with a Western art world that was otherwise mediated only through magazines, articles and occasional exhibitions. An advertisement of the period records him selling 'Cambridge' oil-pigments and art equipment from his house, using his status as a Westerner as a guarantee of quality.[8] When that autumn he gave a lecture 'young talented artists', a young art critic, Yanagi Soetsu, was in the audience. Yanagi recalled Leach demonstrating the process of etching 'on the big press he had brought from England. I was one of the audience in which the name of Augustus John was repeated over and over again. I remember the moment even now, when he showed us a fine

pencil drawing of a gypsy girl by John, which he afterwards presented to us.'[9]

The names of Brangwyn, Tonks and John were repeated over and over again, in interviews and articles. That Leach's knowledge of contemporary art was highly partial and limited did not matter in the small and etiolated Japanese art world in which he had found himself. In an article he stated: 'I attended the Slade School of Art in London, the only nursery which has produced vigorous artists in modern England.[10] Yanagi in his turn declared, 'John is the pride of England at the present day',[11] and Leach's reputation grew by association.

Leach had found himself in two worlds. One was the prosperous expatriate community to which his grandparents belonged. When he married his cousin Muriel soon after arriving in Japan, this was their shared family world and one in which their two young sons, David, born in 1911 and Michael, born in 1913, would be brought up, a community of weekly 'at homes', of summers in the resort of Karuizowa and rock-climbing expeditions in the mountains of Hakone.[12] Leach's graphic work of the period rarely shows Japanese landscape from anywhere else, indeed he rarely travelled far from this known territory. This conventional world is rarely mentioned in his autobiographical writings.

The second world was to be the crucible of his involvement with Japan, and was to mediate his awareness and circumscribe his knowledge of the country and to provide him with the key friendships of his life. This was the world of the *Shirakaba* – the 'White Birch'- movement. It was a small group of affluent artists, intellectuals and poets who had studied together at the Gakushuin (the Peer's School) and the Imperial University. They were privileged young men of the same mould as Leach: passionate, discursive and often enthusiastically muddled. The *Shirakaba* has been described as a 'blend of old-fashioned libertarianism, self-involved idealism, and a fundamental cultural conservatism.[13] This meant its members defined themselves as 'the Rising Generation', as a 'New Japan' that would bring together the best parts of western artistic life and the best parts of an increasingly threatened Japanese culture. The *Shirakaba* movement saw itself as a counterbalance to the endemic industrialisation that had swept Japan in the latter part of the *Meiji* Era (1868–1912).

Leach was rapidly absorbed into the *Shirakaba*. He was to write revealingly in 1914 of the *Shirakaba*'s self-image: 'For fifty years Japan has absorbed the materialism of Europe, at the present moment the advanced thinkers are breasting the new wave of dynamic and synthetic thought which has recently inundated the West.'[14]

These 'advanced thinkers', amongst them the novelist Shiga Naoya and the painter Kishida Ryusei, were in the midst of 'their "Wunderjahre" in quest of artistic life',[15] as Yanagi wrote. The movement's journal, also entitled *Shirakaba*, that he edited shows the almost febrile excitement of the period: there are articles on Rodin, Van Gogh, medieval mysticism and Walt Whitman. The journal is remarkable for the complete absence of writings on Japanese art. Blake was a discovery of particular excitement: he was seen as prophetic, arcane and, most importantly as anti-intellectual. In a special issue of the journal Yanagi favourably compared him with Michelangelo and Dürer and Leach supplied the Blakean cover, an image of *Innocence and Experience* under the lettering 'Tiger, Tiger'. Both this issue and Yanagi's subsequent book on Blake which was dedicated to Leach who stimulated his

'eager reading and appreciation',[16] are indicative of their syncretising of images and ideas. An example of Leach's direct influence is that under his tutelage Kishida Ryusei produced etchings entitled *Creation* showing tortured naked biblical figures.[17] Leach suggested that Blake was in 'profound harmony' with Post-Impressionism and with Whitman. Indeed Blake was central to all his concerns: 'I have no wish to write about Blake in a critical mood, not analytically, nor in a measured way.[18] This breathless language is characteristic of the growing friendship between Yanagi and Leach. 'We dealt authors and artists like playing cards: Sotatsu for Botticelli, Rembrandt for Sesshu.'[19] In Yanagi's journals there are lengthy lists of books bought and devoured: their joint bookplate is in the front of Ernest Fenellosa's book on Japanese Art.[20] Leach was rapidly absorbed into the *Shirakaba*: 'I remember one night at a gathering in [Yanagi's] house opening a parcel of large and fine German colour reproductions of paintings by Cézanne and Van Gogh, the first to reach Japan. Amazement was followed by excited talk. From that room all the pages of *Shirakaba* enthusiasm spread all over Japan.'[21]

It is also clear that great enthusiasm took the place of great knowledge. In this world of metropolitan salon life the habitual way of communication often comes across as pompous and aphoristic rather than considered. Blakean aphorisms were exchanged by Leach – 'Art Springs from Life. All primitive art is symbolic'[22] – and by Yanagi – 'Orientals are essentially the born mystics. New Japan demands human religion'.[23]

A self-portrait by Leach from this period, described by a Western art critic of the time, shows the fervour of Leach's contemporaries: 'something has come into his work since the significant year of 1914 when the Nietzschan self-portrait was done, a face gaunt with deep brooding, eyes hollow and indrawn to the teeming vision of the world he was aching to give outward, visible form.'[24] This 'second world' to which Leach belonged positively encouraged 'deep brooding'.

If Yanagi was to encourage Leach's philosophical ambitions it was another Japanese friend, from outside the movement, Tomimoto Kenkichi who was to open the door to his growth as an artist. Tomimoto had studied architecture and interior design at the Tokyo School of Fine Arts. In 1908 he had gone to Britain and studied stained glass, spending days sketching metalwork, glass and ceramics at the Victoria and Albert Museum. Like Yanagi, Tomimoto came from a well-to-do family and spoke good English. Unlike Yanagi he was a practising artist, and Leach responded to his fluent drawing and pattern-making. Tomimoto brought to his friendship with Leach an informed interest in the possibilities of decorative art, a knowledge forged in London museums and by studying William Morris and John Ruskin. It can be seen in the measured articles he wrote for small avant-garde Tokyo journals and in his

2
Cover of the
*Shirakaba* magazine
1913
Woodcut
Mushanokoji Saneatsu
Memorial Hall

3
*Self Portrait* 1914
Soft-ground etching
19.9 × 14.9 cm
Japan Folk Crafts Museum, Tokyo

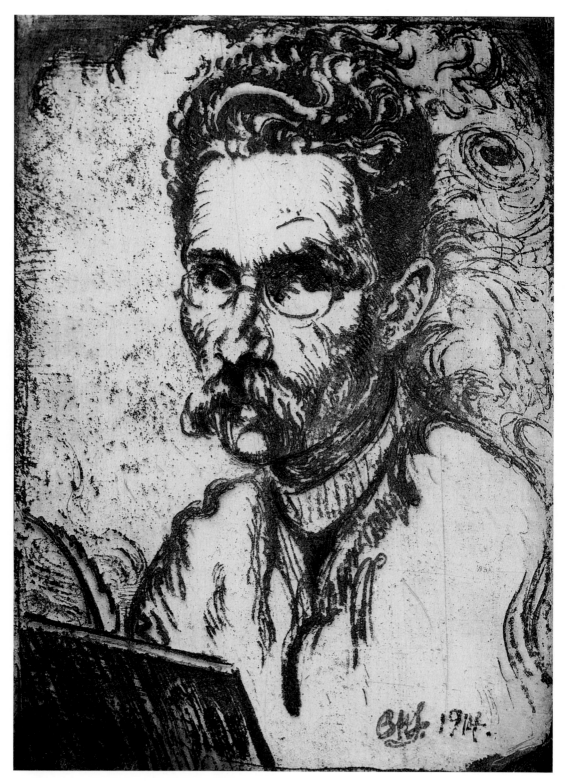

pattern notebooks of the period. If it was from Yanagi that Leach had learnt about European medieval Western mystical traditions, it was from Tomimoto that he learnt about medieval art.

After visiting a gallery in Tokyo together to talk of a shared exhibition, Tomimoto and Leach were invited to a party where 'some thirty young artists, writers and actors, [were] for recreation … painting pottery'. What happened next became an iconic moment in Leach's life: 'brushes and saucers of colour were lying about, and presently a number of unglazed pots were brought in and we were invited to write or paint upon them. I was told that within an hour's time these pots would be glazed and afterwards fired in a little portable kiln … I struggled with the unfamiliar paints and the queer long brushes, and then my two pots were taken from me and dipped in a tub of creamy white lead glaze and set around the top of the kiln and warmed and dried for a few minutes before being carefully placed with long handled tongs in the inner box or muffle … In about half-an-hour the muffle gradually became bright red and the glaze on our pots could be seen through the spy-hole melted and glossy. The covers were removed, and the glowing pieces taken out one by one and placed on tiles, while the glow slowly faded and the true colours came out. Another five minutes passed and we could gingerly handle our pots painted only one hour before.'[25] He was 'enthralled … on the spot seized with the desire to take up this craft'.[26]

Leach had participated in Raku. Raku is the art of making low-fired earthenware ceramics. It was an art born out of the practice of the tea-ceremony and it continued to have strong links with the lives of connoisseurs and amateur artists. It was an accomplishment: many poets and artists practised it, just as in educated circles in Edwardian England a facility with music or water-colour painting might be presupposed. As practised by his friends it was less about making pots than about decorating a surface with colour; as such its appeal to Leach lay in its immediacy as a decorative art. Its brushstokes gave an extra dimension to the line that Leach understood through etching.

Casting around for tuition Leach was recommended an elderly artist-potter, Urano Shigekichi (1851–1923),[27] known by his adopted title Kenzan VI. The great and famous tradition of pottery to which Kenzan was heir had

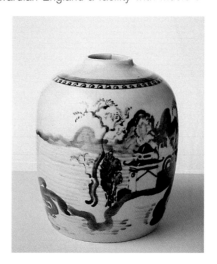

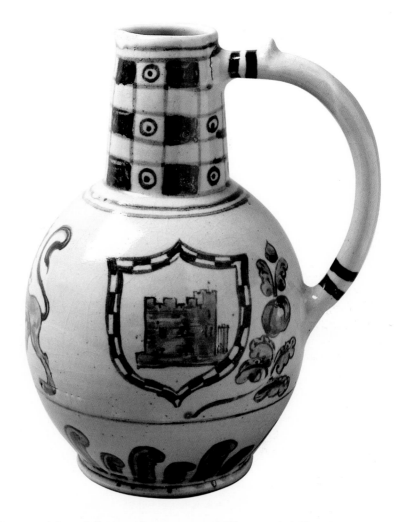

become debased. Kenzan VI was poor and little regarded. The idiosyncrasy and vigour of the pots of the seventeenth-century Kenzan I, with their highly allusive forms and their self-conscious assimilation of poetry and image had, two centuries on, become unsophisticated and slapdash in the work of his successors. What had once been a quietly associative reference to a poem in an image was now clichéd. In Kenzan VI's workshop Leach learnt the first rudiments of pottery-making: throwing at a wheel and decorating. Tomimoto came as his interpreter at first, before starting to make pots himself. Later Leach was to be adamant that in these first pots he was not copying the Kenzan tradition, but this is disingenuous. His early work incorporates a huge array of imagery, of lettering, oriental calligraphy and poetic stanzas. It was highly referential, both in form and in colour, in the manner of the Kenzan tradition. Some pots are direct interpretations: one porcelain ginger jar with blue cobalt decoration is marked 'BHL, painted in Japan after a Chinese piece, 1912'. Another stoneware jug has European heraldic motifs of a rampant lion and shields with crests with revealing allusions to German pottery.

In these first pots it is possible to see what the young Leach had looked at the previous day. As in his contemporary writings these works show a discursive welter of influences, bound together with the vibrant colours that are

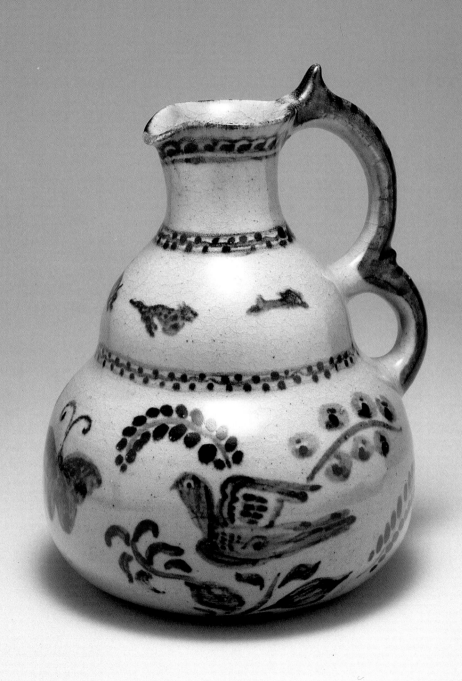

possible to achieve at low temperature, and with broad pattern-making. What joins them together is that they are decorative; they belong firmly within the sphere of the non-functional art object. Some are even named. In this they reflect the context of their inception and their reception: an urbane literate group of cognoscenti for whom these kind of ceramics were appreciated art-forms, not objects for daily use. This was to be an inheritance that Leach carried throughout his making life.

The visible and outward sign of this inheritance was when Kenzan VI built a small kiln for Leach and subsequently gave him and Tomimoto the sealed proof of accession to the name of Kenzan. This meant that Leach could, and frequently thereafter did, use the title Kenzan VII. Given Leach's status as a Western artist and Kenzan's as a paid teacher, the significance of the trans-ference of this title after only a year, to someone who could barely speak Japanese let alone fully comprehend or literally read the allusions implicit in the tradition arouses curiosity. It has, however, been an unremarked constant in descriptions of Leach's mythic 'grounding' in Japanese ceramics.

Ceramics were from now on a continuous part of Leach's life. The cata-logue of the *Shirakaba* exhibition of 1912, for example, records Leach as showing fifty etchings, drawings and oil-paintings but also about 120 pieces of pottery and porcelain, including plates, cups, tea-sets, jugs, bottles, vases and toys. These ceramics were far from cheap, as the price list reveals. In the 'literary supplement' that was published to coincide with Leach's Tokyo exhi-bition of 1914 a picture of a Raku lidded jar is used on the cover. In this booklet, a miscellany of reminiscence, aphorisms and poems, etchings, draw-ings and photographs of pots, Yanagi published an essay on the *Art of Bernard Leach*: 'Mr Leach's taste is … rich in decorative quality. His interest has been aroused and his taste stimulated by coming into contact with the old ceramics of China, Korea and Japan. The love for primitive folk art combined with this newly awakened taste has made of him at length a porcelain artist. His development in this keeps pace with his etching and painting … in many of his designs there is a naïve power and a warmth of breadth of colouring.'[28]

Leach's ceramics were appreciated because of their very lack of technical facility, just as in his etchings of the period there was a transparency of tech-nique that is self-consciously mannered. He knew the very great limitations of his technical expertise, but stressed that his aesthetic was of an another order, writing disparagingly that 'Everywhere in Japan manual dexterity has become the criteria of the applied arts'.[29] In this context Yanagi's comment on his 'naïve power' was praise indeed – it placed Leach in the context of Blake, Whitman and Gauguin. Leach was exhibiting ceramics alongside his graphic work: his career was in the ascendant. It is characteristic that it was at this point that Leach decided to leave Japan.

Leach had become involved with a Prussian Jewish writer based in China called Dr Westharp, 'a living influence here in the East'[30] through reading his views in Tokyo journals: 'I have been convinced by a certain Dr Westharp in Peking that my whole attitude towards Life and Art suffers from the curse of Dualism. A separation of thought and act, will and deed, which I believe is at the root of the rottenness of our Western life.' Westharp's ideas expressed in his books *Education Through Freedom* and *Regeneration Through Education* are a muddle of the views of the Italian educationalist Maria Montessori, and the theories of eugenics and Pan-Nationalism. Leach, ever

7
Jug 1913
Stoneware
H.14.5 cm

Holburne Museum and
Crafts Study Centre, Bath

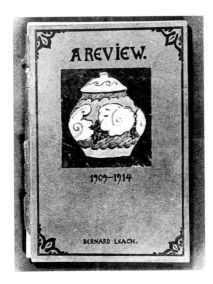

receptive to the appeal of larger abstractions, rapidly became a passionate advocate. He wanted Westharp to meet Yanagi at once: 'Dear Yanagi, In the reply which I have recently had from Westharp he says 'I should like Mr Yanagi not to make any reference to me in writing before he knows my ideas really and thoroughly.' He goes on to say that he would gladly meet the members of the Shirakaba, preferably at evening in a garden with music.'[31]

Yanagi was equally circumspect: 'I should like Dr Westharp not to make any reference more to the thought of Japanese people in his writings before he knows the ideas of the young Japanese generation really and thoroughly'.[32] The meeting between the philosophers did not occur. Instead Leach, feeling 'the need of a leader', moved his discipleship to Peking. Westharp, he felt, was someone who could focus his 'groping thoughts on the Occident and the Orient'.

Between 1914 and 1916 Leach made three visits to Peking. On leaving Japan he was clearly setting his sights on a new life as a philosopher. Yanagi wrote to him of these aspirations: 'which aspect will your future reveal – you as an artist, or you as a moral pursuer? I don't know. But to which world you were chosen? I, personally as well as affectionally [sic] love you as an artist … I value your artistic work much more than his philosophical ideas.'[33]

It was to be an experience that ended in profound disillusionment. Leach became a factotum: his first duty was to type Westharp's new book *China Anti-Christ* and his views were not solicited. He found himself less suited to this new role as a moralist than he had expected when he had written that he was leaving Japan 'and am not expecting to return to work but hoping to go to China and India … to gain a wider and deeper grasp of the meeting and unification of East and West'.[34] In the vacuum of Peking life with Westharp he needed little encouragement to be persuaded finally by Yanagi to return to Japan. Yanagi offered Leach the possibility of exhibitions and he offered him the chance to live and work with him in the burgeoning artistic community in the village of Abiko outside Tokyo. 'Your friends are waiting for you … Your room in Abiko is now ready.'[35] In 1917 Leach returned to Japan, determined to live as an artist and as a moral philosopher in more agreeable surroundings.

A pen-and-ink sketch by Leach shows Yanagi in his study at Abiko. He is sitting dressed in a kimono, but in a Western rocking chair. There is a gas lamp on his desk. Behind him on a shelf above his books are a lit incense burner, Chinese pots and Rodin's small figure *Standing Man* given by Rodin to the *Shirakaba* group.[36] A visiting Western writer vividly described the impression made on him by Yanagi's surroundings: 'I found my prophet in a cottage. It was a cottage overlooking rice fields and a lagoon. From the Japanese scene outdoors I passed indoors to a new Japan. Cezanne, Puvis de Chavannes, Beardsley, Van Gogh, Henry Lamb, Augustus John, Matisse and Blake … hung within sight of a grand piano and a fine collection of

8
*A Review 1909–1914*
1914
22.2 × 15 cm
Holburne Museum and Crafts Study Centre,Bath

9
Raku Vase 1913–20
H.13.7 cm
Private Collection

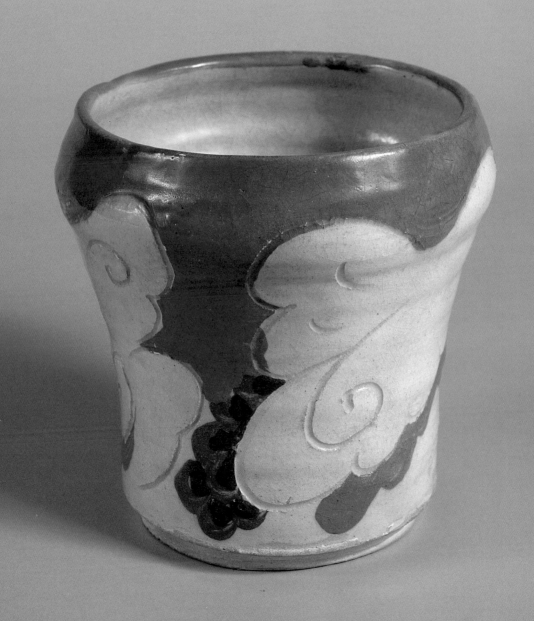

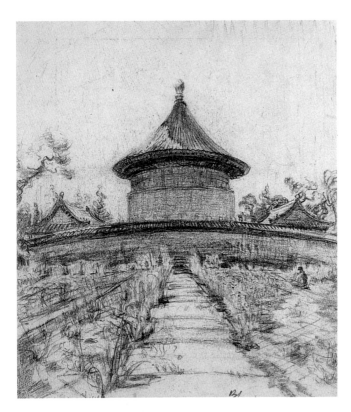

European music. Chinese, Korean and Japanese pottery and paintings filled the places in the dwelling not occupied by Western paintings.'[37]

There could be few better illustrations of Leach's Japanese milieu. It was a world in which contemporary bohemian concerns were well to the fore: Abiko had as its residents the novelist Shiga Naoya, and Mushanakoji Saneatsu, the educationalist whose 'New Village' project of agricultural and educational reform was close by. Leach lived with Yanagi and his lieder-singing musician wife. Abiko was also extremely pretty, a hamlet on the banks of a small lagoon, yet only one hour and a quarter by train from Tokyo. It could not be described as a commune, but, like Eric Gill's Ditchling in the 1920s, a community of like-minded artists and writers who defined themselves against a metropolitan culture while remaining close to it both geographically and intellectually. Leach's unusual place in this community was described by E.E. Speight, a visiting art critic, as 'a fine object lesson of … happy dovetailing into such a delightful region of Japanese life. Nobody but an artist could ever hope to have the privilege of such intimacy, of course'.[38] Unsurprisingly one of Leach's major concerns began to be that of 'folkcraft'; of the character and vitality of the surrounding country crafts. This was to play a significant part in Leach's work in Abiko.

Leach had a Chinese-style studio built with an extravagantly tiled roof and round doorway. He purchased Kenzan VI's small kiln and had it rebuilt next to the studio: a small stoneware cup of 1919 shows both constructions. His pottery of this period is as wide-ranging in form and decorative content as it was before his Chinese excursion. In materials it encompasses porcelain, stoneware and Raku with some overglaze enamel decoration inspired by Japanese porcelain. But some of his pots also begin to show the influence of

10
*Temple of Heaven, Peking* 1916
31 × 27 cm
Pencil drawing
Mashiko Reference Collection

11
Bernard Leach and his kiln at Abiko, Japan, in 1919
Holburne Museum and Crafts Study Centre, Bath

12
Yunomi 1919
Stoneware
H.9 cm
Holburne Museum and Crafts Study Centre, Bath

early Chinese work, the Sung dynasty wares (960-1279) now starting to be exhibited and acclaimed in Tokyo. These seemingly simple pots, like the Korean ones that Leach and Yanagi had seen on their brief joint collecting trip to Korea in 1918, appeared to be more 'authentic' than the later, more decorated wares. Leach started glazing some pots in celadons and deep iron-black glazes in response to these pieces.

In Abiko, however, a new and significant influence is discernible in his Raku ware. The edges of his dishes are covered in a network of small cross-hatching and lettering becomes larger and more integrated with the pattern making: he had discovered English slipware. Not, of course, at first hand. Until this point Leach had been completely in the thrall of Oriental pottery except for a few old Delft and German pieces seen in the Tokyo museums. Now through Lomax's *Quaint Old English Pottery*, bought by Tomimoto at a Tokyo bookstore, an English folk pottery tradition of great complexity was revealed. The appeal of the slipware dishes and jugs was manifold; it was a decorative tradition where a central image was privileged and so the need for

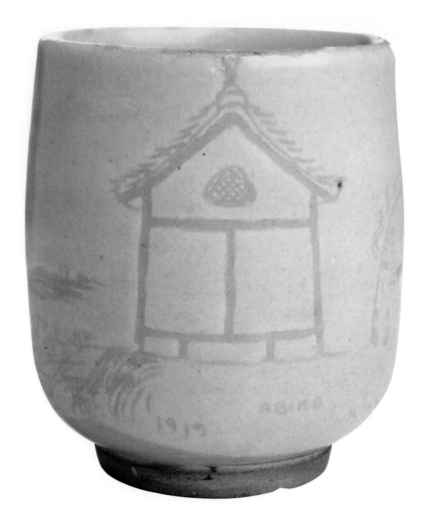

pattern making in the round was avoided. There seemed to be a good historical grounding here for pottery that crossed the boundaries of being either straightforwardly utilitarian or decorative. Crucially, it gave value to lettering on pots in a way that Leach had been struggling to comprehend within the complexity of the calligraphic Kenzan tradition. It allowed pots to be titled or signed in obvious ways, and above all it gave Leach, whose growth as a decorative artist had taken place completely in the East, some sense of famous Western potters. He signed the hare dish given to Yanagi ('it will become my lifelong friend'[39]) in the stylised manner of Thomas Toft, the seventeenth-century potter whose pots were the subject of a substantial part of Lomax's book. As Leach stated, 'This was my first attempt after having started making pots in an alien country to get my feet on the ground of English tradition'.[40]

For Leach this focused his thinking for the first time on how he was drawing on traditions from both East and West. In an interview in 1919 he compared his situation with that of Koetsu, brother of Kenzan I, who, he said, 'was not an individual, independent free-thinking' man: 'It was his main business faithfully to carry on a tradition, to rely on family, guild or craft. We have no traditions to

13
Bernard Leach
decorating the Hare
Dish, 1919 (see fig.14)
Holburne Museum and
Crafts Study Centre, Bath

14
Hare Dish 1919
Raku
Diam.21.3 cm
Japan Folk Crafts Museum,
Tokyo

carry on; factories, city life, science, education (and) travel have taken the old shelters from us ... We are tired of the family system, our guilds, our trade unions. All the folk-law, the country traditions which determine the shape, size and pattern of all decorative objects is dying out.' In this article, published in a Tokyo English language newspaper in 1919, he asked 'On what basis does the modern craftsman stand?'[41] In an interview between Leach and a reporter conducted to mark Leach's exhibition, the answer seemed to be self-evident:

From painting and etching [Leach] has been drawn in late years to the crafts, and many promising experiments have come from his kiln at Abiko. This year he has worked at furniture as well as pottery and the exhibition which he opened at the Ruisseau Gallery in Kanda yesterday shows his first attempts to design and make household furniture suitable to Japanese conditions of life and embodying European as well as Oriental ideas of decoration. [There are] articles ... and ... tables, chairs, desks, bookcases, lamps, stove, sofa and also textiles and pottery. 'I believe that there is need for such an effort' he says and everybody who has been in a Japanese 'foreign' room will agree with him 'and I believe that Fate has thrown this work in front of me.'[42]

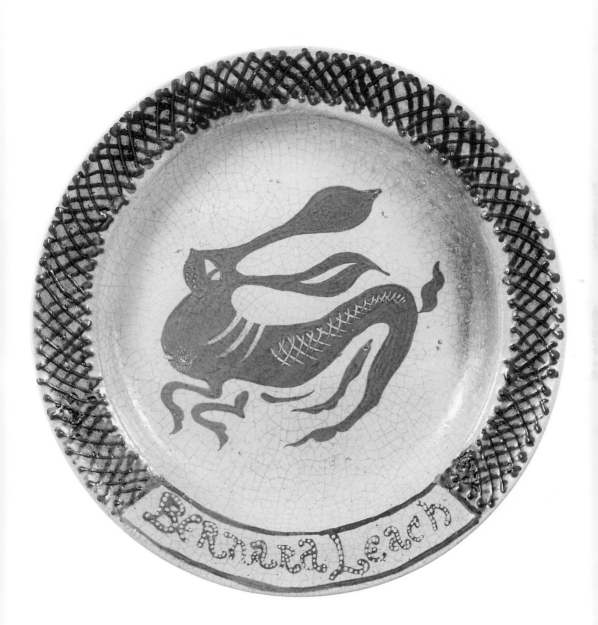

The 'effort' that Leach had identified and elected himself for was the adoption and synthesis of dying, archaic traditions and their application to *every* facet of contemporary living. He and Tomimoto had long talked of this. Tomimoto had experimented in his own studio designing leatherwork, textiles and furniture, with Morris always before him as an example of dedicated investigation. He wrote: 'When I think of the time and effort Morris had taken, without help or teaching from others, in dissecting the details [of old carpets] and in carrying out many trials until he could weave them on his own, my respect for this man seems to acquire even more lustre.'[43]

But this was to be a different experience for Leach: the making of objects himself was of only minor interest. 'The modern decorative artist' was to lead; artisans could make under supervision. Examples of Leach's work of this period are the three-legged chairs he showed at the Kanda exhibition. These chairs with their pierced holes, scrolled tops and deep crosshatching marks along their backs owe nothing to local vernacular or 'tradition', Japan then being a chair-free culture, and everything to a synthesis of Leach's designed lines and the local carpenter's use of cedar. The country carpenter he in-

15
An exhibition of
Bernard Leach's work
at the Ruisseau
Gallery, Tokyo, in 1919
Holburne Museum and
Crafts Study Centre, Bath

16
Desk designed by
Bernard Leach, 1919
Holburne Museum and
Crafts Study Centre, Bath

17
Tea wares: teapot, cup
and jug 1919
Stoneware
Max. H.14.5 cm
Holburne Museum and
Crafts Study Centre, Bath

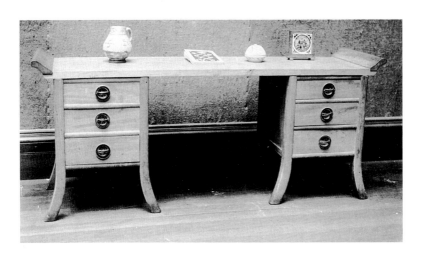

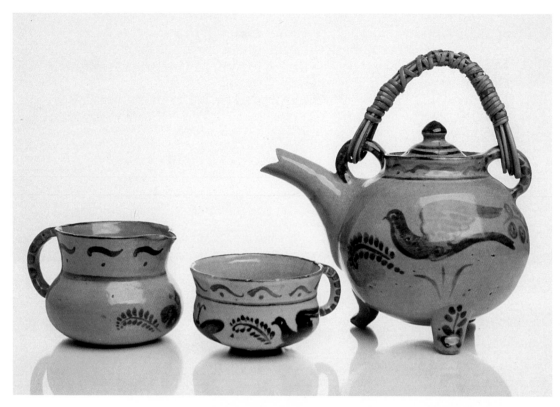

structed was better than his urban counterparts, Leach told his interviewer, because he had 'no high collar ideas'.[44] 'High collar' referred to the young Westernised city clerks with their Western dress – it was contemporary shorthand for urban, chic, stylish and fashionable. The transaction between Leach and the carpenter, like that with all the experienced potters who throughout his career assisted him and threw pots for him, demonstrated by their behaviour 'the right relationship between artist and artisan'.[45]

In the same 1919 interview Leach called this making of everyday objects a 'democracy in art'. This 'democracy' was of a very particular kind. That he expected handmade decorative objects to be expensive, collected and appreciated by a patrician class is clear from their manufacture and promotion. This was work that could *only* be appreciated by a small group of Westernised Japanese aesthetes or Westerners living in Tokyo. It was 'everyday' in only a very localised way. For instance, Hamada Shoji, a young and serious ceramics student visiting the exhibition, noted: 'Heads for women's hat pins in Raku pottery and in porcelain. All of these things were very close to life, to living, and very exotic and very unusual.'[46] But Leach's 'democracy', if it did not extend to either the creation or the sale of art objects of this kind, was to be achieved differently. He wrote: 'in the future they will be replaced either by machine-made goods, or by artist-craftsmanship. Craftsmen will be creative artists and the machines will fulfil their true democratic purpose by reproducing designs for wide and cheap distribution.'[47]

Artist-craftsmen were to be the catalysts for cultural change. They had volition and the necessary sense of context to bring the best of the East and West together. Otherwise crafts would be left in the hands of those who 'stumble badly when it comes to modern things',[48] folk craftsmen possessed

by unchosen and deadening tradition. Leach is categorical in this point: folk craftsmen had skills but lacked the self-consciousness that would allow interesting objects to be made. In anatomising the situation of artists and craftsmen in an industrial society in this way Leach reflected the current excitement felt in his circle by the ideas of Ruskin and Morris. There were many contemporary interpretations of their ideas for Japan. His oldest Japanese friend Takamura Kotaro had sculpted a bust of Ruskin in his homage and other friends and his neighbours such as Mushanakoji Saneatsu were involved in Ruskinian attempts to found a 'New Village' at Abiko.[49] Leach felt himself to be in the vanguard of this situation. Western concepts were about to revivify the arts in Japan. . As he put it in an article: 'The keys of life which young Japan accepts from the hands of Tolstoi and Cézanne may even open the ancient granaries of the East.'[50]

Leach's position within this world was unassailable; no-one else could claim, as he did in a lecture in very basic Japanese in 1920 (and published in literal translation by Yanagi), such a Ruskinian inheritance: 'I thought of John Ruskin as my father ... I thought he was beautiful and I still like him very much ... He was very serious man.'[51]

At this high water mark of popularity and success in Japan Leach began to formulate plans for a return to England. These plans soon became extended to involve Hamada Shoji. Hamada had followed Leach and Tomimoto's work, tracking it through exhibitions in Tokyo, as he followed his exacting studies in glaze chemistry at the Ceramics Institute in Kyoto. Hamada had gradually become more and more dissatisfied with the putative life he would have as a potter in Japan and the model of Leach's life seemed exciting and liberated in contrast. A first favourable meeting at Abiko was followed by a lengthy correspondence, Hamada revealing his great technical expertise in answer to the lacunae in Leach's knowledge of glazes. It was decided that Hamada would come to England, in Leach's words, as a 'good Japanese assistant'.[52]

Leach's departure from Abiko was forced upon him. In preparation for his final exhibition, sparks from a kiln set fire to his studio roof, destroying the studio and its contents. Everything was lost except for the pots in the kiln – all his work, from furniture,through glaze notes to prints. The situation was saved through the generosity of an aristocratic patron, Viscount Kuoroda, an artist trained in Paris. He offered Leach a kiln in Tokyo with assistants to help him. This final year in Japan was therefore spent with 'experienced potters who managed my new workshop and kiln so admirably', and was a great success.[53]

The technical quality of these last pots was noticeably higher than anything he had achieved so far, due to the skill of his assistants as much as to his increasing technical facility. In his technical notebooks of the period are lists of instructions given to his assistants of their weekly work, and their duties included throwing pots in true artisanal spirit for Leach to decorate. In a review of this final exhibition in Japan, reference is made to the '2000 pieces of [pottery] which have been turned out from Mr Leach's kiln in Azabu since his last show was held. The later pieces show marked development and the artist's technique has improved with the experience acquired by assiduous practice'.[54] An 'exceptionally large number of people' visited this exhibition resulting in a 'record number of sales'. A small booklet was published by his friends to mark his impending departure entitled *An English Artist in Japan*. It includes tributes by Yanagi, Kishida, Ryusei and Tomimoto, and

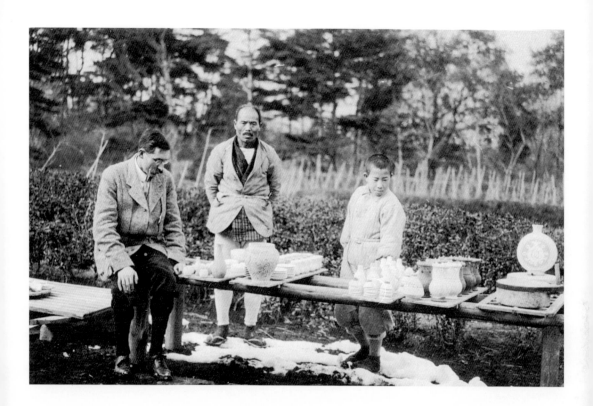

18
Bernard Leach and his
Japanese assistants in
Tokyo in 1919

Holburne Museum and
Crafts Study Centre, Bath

poems, aperçus, etchings and drawings by Leach. Photographs of pots were also included. Valedictory dinners were held. Yanagi wrote 'I consider his position in Japan, and also his mission in his own country, to be pregnant with the deepest meaning.'[55]

In the summer of 1920, after twelve years in the East, Leach, his family and Hamada Shoji set sail for England. There were high expectations on the part of his Japanese friends: his 'mission' was 'to make pottery under circumstances which offer unusually favourable opportunities for the development of his art.'[56] Leach himself anticipated great things.

# 2
# Necessary Pots
## 1920-1940

St Ives, a small fishing port in Cornwall, is at the furthest extremity West from London. It had become a fashionable art colony in the 1880s, attracting artists from all over Europe with its combination of clear strong light and picturesque local life, and became well known for landscape and genre painters. By 1920 its status was more equivocal, becoming equally known for a particular kind of slightly old-fashioned seascape painting and as a popular seaside resort. Leach's place within the often labyrinthine internal politics of the St Ives art world, a world of exhibiting societies and arts clubs, was problematic from the outset. Though close and important personal friendships would develop with other local artists, in the early days he was regarded as a curiosity: 'The Art Potter of St Ives'. This was a pertinent reflection of a general uncertainty in Britain as to the place of pottery within the hierarchy of the arts.

Decorating pots, in other words painting surfaces, in the manner of the previous generation of artists inspired by William Morris was by 1920 highly respectable. Making pots was considerably less rarefied. At one of the few art schools to teach ceramics, Camberwell School of Art, a local thrower was employed to produce pots to the designs of the students. Without tuition from such professionals it was difficult to learn anything of the technical side of pottery. There was little written on the subject and no kilns were commercially available for the independent art potter. This meant that those few pioneers, for whom the making of pots was as important as their decoration, were, in the most part, autodidacts and they were often on parallel paths of technical research. That the language used to discuss them was of the 'mysteries' and 'secrets' of the potters art was not mere cliché: it reflected the practical challenges they faced and the lack of knowledge on the part of writers. But these words also reflected an interest in the recently-excavated early Chinese pots of the Sung Dynasty. A major exhibition of them was held in London in 1910, and their austerity of colour and form was hugely influential as in Japan. They seemed to be a completely different kind of Chinese pot from those familiar from the museums: 'natural' country pots rather than court wares. Their decoration was spare and asymmetric, their colours and textures muted. The 'mysteries' of these Chinese glazes were to be the determinant of much of the early pioneer pottery. It led to considerable virtuosity in the cases of Dora Lunn and Alfred Hopkins; less achieved were Alfred Powell's works ('rotten' in Leach's view). Reginald Wells even marked his pots with a *Soon* seal, in what appears to have been a punning reference to Sung. However, apart from William Staite Murray, a potter also deeply affected by these Chinese pots and a man whose career was to entwine with Leach's in both reputation and influence, these potters made work that smacked more of 'sophisticated imitation' than personal interpretation of their sources.[2]

The public for these Orientalist art-pots, non-functional and esoteric as they were, was small. It was made up of collectors and makers that appeared to be in a decline from a highground of Arts and Crafts Movement idealism. Michael Cardew, Leach's first apprentice, characterised this world as 'old and stuffy, over-upholstered and decaying, cobwebby, sticky and contaminating'.[3] It was not a propitious time to start an art pottery in England.

The St Ives pottery was started 'as an independent branch of the St Ives Handicraft Guild, by myself, in partnership with Mrs Horne, to whom the Guild belongs'.[4] With their joint capital Leach bought a strip of land bordering a fast-running stream on a hill outside St Ives. A studio and a cottage were built and Hamada and Leach, with local workmen, constructed a wood-burning climbing kiln. The geography of St Ives resulted in severe technical problems that were to become a constant in Leach's early working life. Cornwall lacked not only any quantity of suitable timber for the kilns, but locally available clays were of poor quality. The exiguous quality of these raw materials can be said to have defined the way in which his work developed: Leach's search for technical improvements was accompanied by his commentary on the relationship between technical expertise and aesthetic success. Of the Raku ware that was a crucial economic part of his early output he wrote that 'people make such a fuss when they find it porous'.[5] But by its nature as a technique 'even clumsiness is preferable to suave dullness'.[6] Similarly in his early slipware dishes the way in which they have been fired is evident in the scarified marks on their surface. This can be read as both a lack of firing experience and as indicative of his sensibility; but in this clear acceptance of the impact of visible technical 'deficiency' as an

19
Vase 1926
Stoneware
H.16 cm

The University of Wales,
Aberystwyth

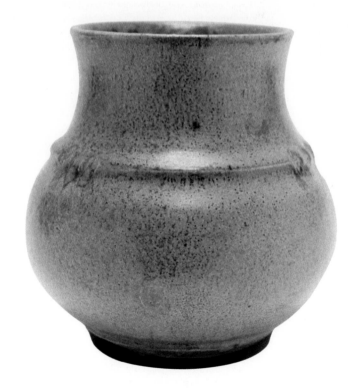

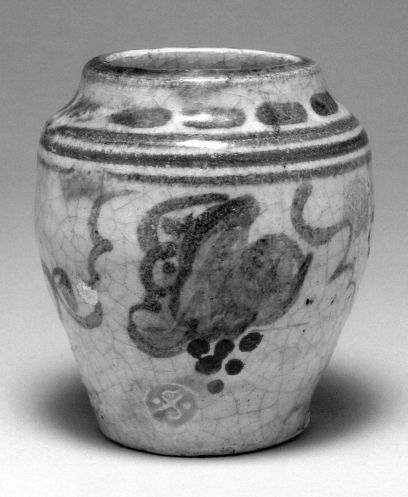

aesthetic Leach was revealing his Japanese background in understanding as well as making pots. Whilst other potters were searching for perfect technical control over their Orientalist glazes, Leach was engaged with the ideas of 'naive power' in technical deficiency that had been a mainstay of his conversations with his Japanese artist friends.

The need to 'make do and get by' meant that aesthetics came up against a real financial impetus. 'I hope to depend', he said in 1923, 'more and more on local materials ... to develop in the finished pottery a basic local character'.[7]

*English Slip-Ware Plate.*

**STONEWARE**
**&**
**ENGLISH SLIP-WARE**
Made by hand of Cornish materials.
The Pottery Showrooms are always open
Visitors may see over the Works on Saturday
mornings.
*July 30th   Demonstrations on Thursday afternoons to Sept. 4th
Teas provided at Pottery Cottage 1/-*

**THE LEACH POTTERY**
**UPPER STENNACK   -   -   -   ST. IVES**

This was, on one level, a straightforward sales pitch. Leach depended very largely for his financial survival on the holiday-makers who flooded into St Ives in the summer. In an article in *The Evening Standard* in the same year the Leach Pottery is described as 'not above making small, inexpensive things for the souvenir-hungry char-a-banc crowds ... which is pleasant to hear, for there is a dearth of genuinely local keepsakes at the holiday resorts'.[8] Visitors were encouraged to decorate Raku pots and take them home.

On another level Leach's growing interest in the history of local slipware and galena (a finely ground lead ore that was a common constituent of some vernacular glazes), manifested in joint expeditions with Hamada to gather pottery shards, was a part of a developing idea of 'appropriateness'. The galena-glazed tankards with Cornish sayings, tobacco jars and jugs that predominate in the early days of the Leach Pottery were an attempt to respond appropriately to the locality. They share, with the large decorated dishes, in being part of a particularly English lexicon of forms. Sometimes the imagery used on these dishes was Oriental (well-heads, willows, pagodas) but often it was local in origin. *The Mermaid of Zennor* and the stylised heraldic beasts fall into this category. A contemporary reviewer was struck by this at Hamada's first London exhibition in 1923: 'Here and there will be found a piece which seems to interpret a traditional British form, the 'cloarn bussa' of Cornwall in the more gracious idiom of the East'.[9]

The exhibition pieces of this period by Leach and Hamada were as ambitious in scale as they were in design. These were not for the char-a-banc visitors. As Cardew wrote:

The very size of the large dishes – some of them measure as much as 20 inches in diameter – makes them a unique and striking decoration in any place; and one or two of them in a fairly large room produce, with very little other furnishings, a wealth and warmth of decoration which could hardly be got in any other way. The proper background for them is probably a small country house of Old English character, and they look their best with white walls or in combination with oak; in fact they are as necessary to the interior decoration of such a house as the Romney Green furniture and the Mairet textiles.[10]

These large dishes are clearly contextualised: they are contemporary reinterpretations of a country idiom in the manner of the other famous Cotswold

**20**
Vase *c.*1924
Raku
H.7 cm
The University of Wales, Aberystwyth

**21** *Above right*
Handbill advertisement for the St Ives Pottery
Holburne Museum and Crafts Study Centre, Bath

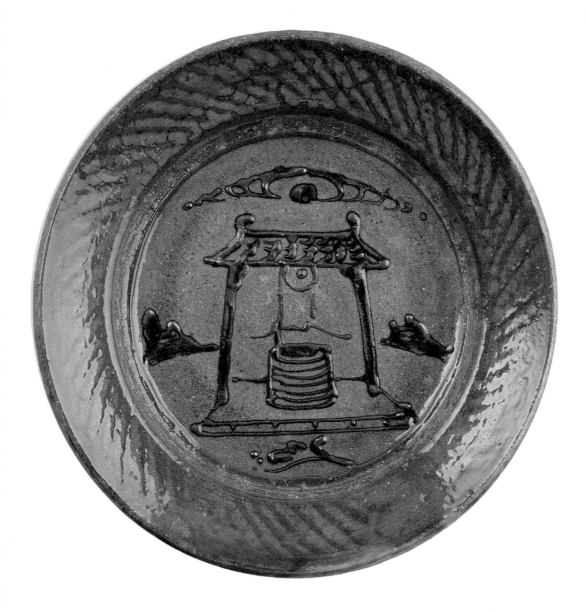

**22**
'Well' Dish 1925–30
Earthenware with
slip decoration
Diam. 33.5 cm

The Wingfield Digby
Collection

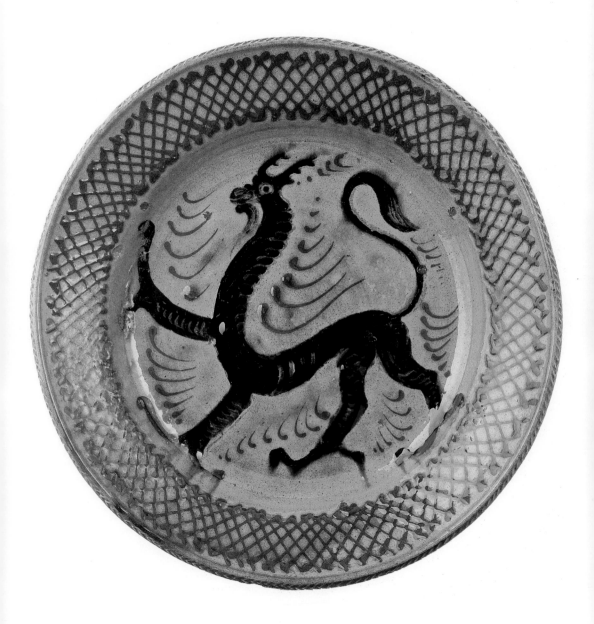

23
'Griffon' Dish 1929
Earthenware with
slip decoration
Diam.46 cm

The Wingfield Digby
Collection

artist-craftsmen mentioned, Romney Green and Ethel Mairet. They harmonised, as Leach was to say, 'with the whitewash, oak, iron, leather and pewter of Old England'.[11]

Leach was not alone in this endeavour to recreate a particularly English feeling in pottery. As early as 1900 Reginald Wells was experimenting with slipware made from local materials, and others were interested in the idea of an 'authentic' identity in pottery. It was the arrival of Michael Cardew at the Leach pottery in 1923, just as Hamada was to return to Japan, that gave Leach his greatest help in engaging with these ideas. Cardew, a young Oxford classics graduate, had come into contact in childhood with one of the last remaining folk pottery traditions in England, the slipware of North Devon. His passionate advocacy of this ware, with its robustness and breadth of decorative technique, impressed Leach. It seemed to provide Leach with a genuine model for making more than just exhibition pieces. This was not an uncommon aim at the time, but had inherent problems. A review of a Guild of Potters exhibition commented:

It is a pity that if artists distinguish their work from the produce of a factory it should in the process become artificial and divorced from the traditions of English pottery. One potter's work, a Leach student, was rough and would probably pass for peasants' work. But her pots are well shaped and boldly painted. It is a pity that they would not be useful; for one thing they are too expensive to be used every day. Peasants do not make useless pottery if they can help it, and surely rough pottery should not be merely ornamental.[12]

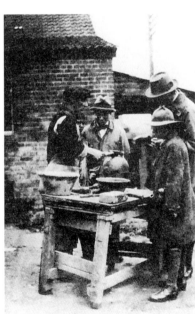

That this work was 'precious and eclectic' seems to have been a common contemporary criticism of this new art-pottery influenced by old folk-pottery. At a major exhibition held in Leipzig, in which Leach showed alongside all the major

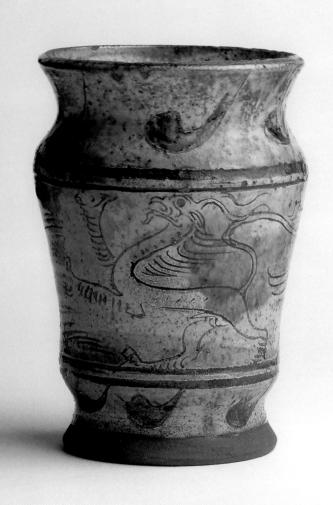

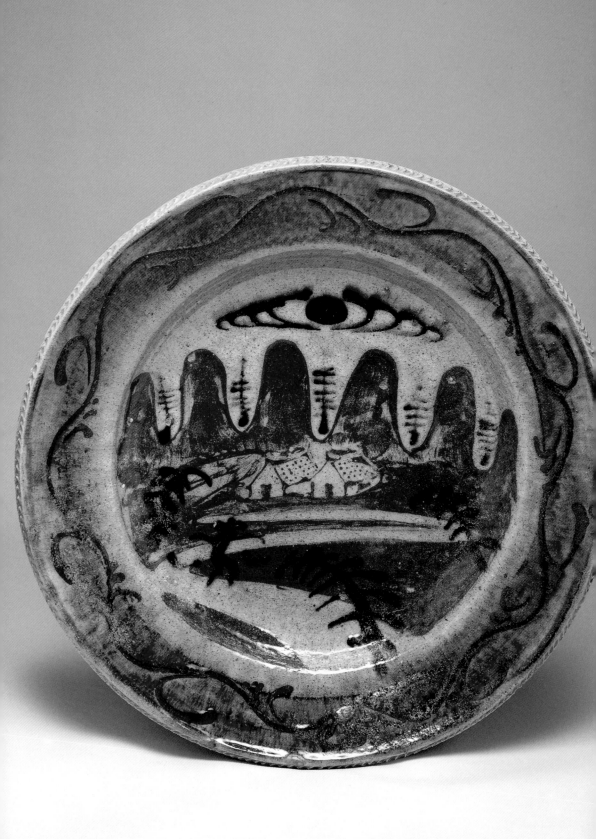

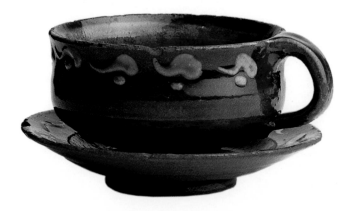

potters of the day, a reviewer noted that 'the Germans frankly think our pots dull', and one critic said 'we do similar semi-peasant designs but do not show it as our first-class work … German artists and the press … all say that we are too slavishly bound to tradition, and the modern movement which is sweeping across Europe has just missed us … Bolshevism in art, as in politics, finds it difficult to get a hold in England'.[13] One friend curtly commented to Leach that 'Peasant work is quite out of place in a modern kitchen … Practically all the slipware I have begins to lose its glaze after a short time. Much of it is porous'.[14] But this did not exercise Leach unduly. It was the lure of an immediate and accessible tradition that had so taken Leach over. This peasant slipware had a totemic place *within* English manufacture. In 1925 Herbert Read and Bernard Rackham, two curators of ceramics at the Victoria and Albert Museum, had made just this point when they juxtaposed slipware as 'the English tradition' against tin-glazed wares or 'Foreign strains' in their book 'English Pottery'.[15]

Leach continued to show his pots in Japan in exhibitions organised by Yanagi. Despite the efforts to supply the tourist trade in St Ives, this provided a crucial financial lifeline. Yanagi, ever sensitive to the nature of the place of traditional folk art in the contemporary world, suggested to Leach that 'Englishness' was a factor in his successful sales of galena ware at a Tokyo exhibition in 1923: 'Galena works nearly all sold. The reason is that we can see in them the free, but Western traditional quality … the other reason is, perhaps, that the glaze colours are fresh to our eyes and our young people are eager for seeking the best of the West'. Yanagi also requested fewer teabowls and more 'tea or coffee sets, you can sell them at once – oh this is modern Japan – can not help'.[16] At a subsequent exhibition he reiterated this request even more cogently:

> It is awfully pity that you did not send us more of yellow galena of pure English quality. You must understand how much we like it. All the pieces which you sent me this time, without a single exception, were sold. The reason is twofold. Firstly, yellow galena is of pure Western quality and suited for the psychology of modern Japanese who live in Western buildings, manners and styles … Secondly, it is beautiful in artistic quality. I myself prefer your well-digested English galenas to the pieces of Sung pattern. Because they are born-pottery, not made-pottery.[17]

Leach's pots of this period show no attempt to synthesise this excitement about native traditions with his deep emotional attachment to Sung pots. In

35

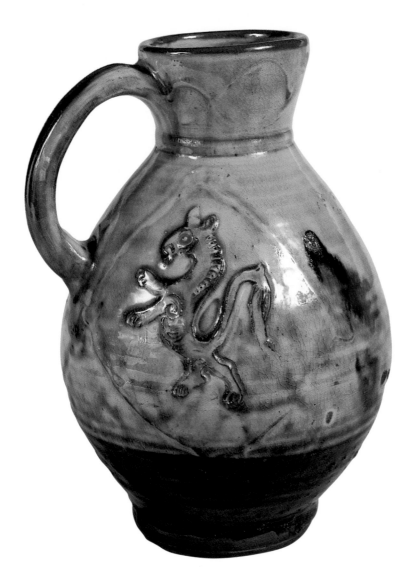

his exhibitions he showed both types of work side by side: pilgrim flasks and bottle vases decorated with patterns cut through slips to the clay body below in an Oriental style next to his English slipware dishes. These Oriental pots were shown on covered wooden stands: in so doing, they pronounced their own specialness and rarity. Some pots were straightforwardly modelled on Sung dynasty pots and were even bought by the greatest collector of Chinese pots at the time, George Eumorphopoulos. The cut-sided, stoneware bowl (fig.31) shows Leach's absorbtion in the ideal of austerity. The foot of the pot is unglazed to show the qualities of the clay: 'The foot is a symbol, here do I touch earth, on this I stand, my Terminus', as Leach was to write.[18] This is undoubtedly one of Leach's greatest contributions to Western studio pottery: the clear exposition of the importance of the tactile values of simple fired clay. His use of unglazed surfaces emphasised the 'local' character of handmade pots: that, unlike industrially glazed wares, they had different, complex, and irregular textures. This was using the Sung pots as a marker of seriousness, clarity and fitness of purpose. They would be used in this way by

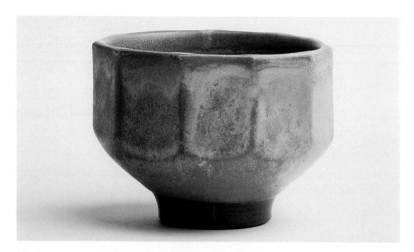

Modernist critics, most notably Herbert Read in *Art and Industry* illustrated alongside contemporary functionalist designs. The Chinese Sung pot seemed to be the clearest manifestation of a growing contemporary concern with 'Truth to Materials'. But in other pots, such as the vase from 1927, the Chinese decorative models are highly stylized, and Leach's decoration becomes diffuse and inchoate.

At this point of his career Leach was not above emphasising the unimpeachable authority he had – his direct involvement with the true fount of Oriental ceramics. His story is a 'romance in itself', as a newspaper put it. He was 'The Potter of St Ives: Englishman who sells to Japan' (*Daily Graphic*, 9 October 1922). This helped Leach define himself in relation to an increasing number of art potters selling to a limited number of collectors. However, his letters betray constant anxiety about his finances – 'We only have £50 left … I am in arrears all round'[19] – and his financial prospects – 'A new man in the field called Vyse had a show just before me and sold £1100 of pots which were really without life but technically wonderful'.[20] Leach's pots were few in number due to the chronic technical problems that dogged him in St Ives as

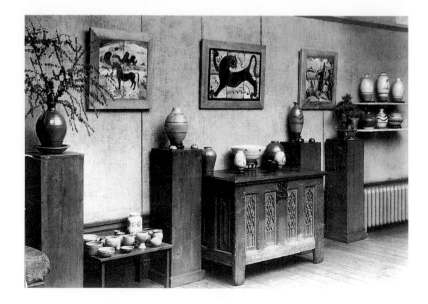

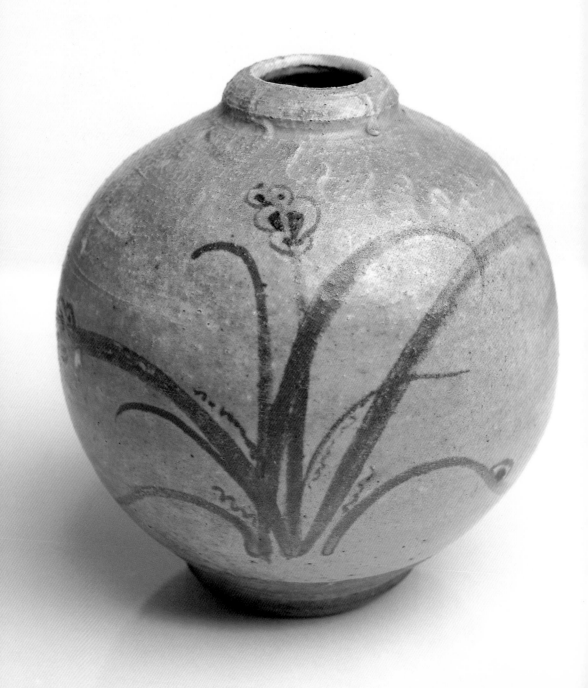

he struggled in seemingly ad hoc ways to address production. One of his students Katherin Pleydell-Bouverie chafed him on one disastrous occasion to remember to keep enough wood in stock to last a complete firing: 'in the Lord's name why haven't you got stocks of wood? My dear, you simply must do that – I am inprovident, am stupid beyond measure, but I've wood for two years ahead always'.[21] His few successful pots, and some cracked ones that were mended in the Japanese manner with an imitation gold lacquer, were expensive. In 1928 at his exhibition at the Beaux Art Gallery his highest price was thirty guineas for a 'Bottle with three small handles' and other pots

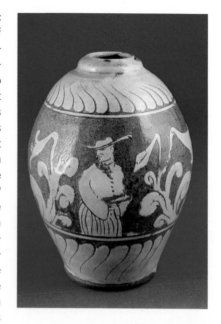

were twenty guineas. These were prices 'only within the range of the collector of rare gems of the potter's craft'.[22] It was becoming clear that he couldn't survive in the manner to which he aspired as an art potter.

Leach's movement, therefore, towards making a more extensive range of pottery began as a matter of expediency: 'everything is so dominated by the damnable shop-minded and the commercial burgher of England. So in spite of the rekognition [sic] of my work as the best it is difficult to sell except to collectors and a small public. I shall have to limit myself to certain things and produce them more cheaply in order to keep going.'[23]

This aggrieved sentiment underwent many shifts in expression during the 1920s but the force behind it remained unchanged: Leach's acceptance of the necessity to make functional ware was not a chosen course. He started making a much larger range of pots and his projected market was a new one. The *Sunday Worker* described the paradox: "'This is the sort of jug a working man would want to have his beer in", said Mr Leach, pointing to a magnificent example of simple modern stoneware. I agreed. Unfortunately, however, owing to economic circumstances of which he is a victim, no less than the working man, the price put upon the jug has to be such that it will most likely end up by adorning the sideboard of a collector of means: I am afraid members of the working-class will not be able to buy any of the beautiful things shown at this exhibition'.[24]

Leach's next attempt to expand the possibilities was simple. If it was

32
Vase *c.*1927
Stoneware
H.14 cm
The Wingfield Digby Collection

33 *Above right*
'Soloman Amongst the Lilies' Vase 1927
Stoneware
H.21 cm
Leicester City Museums

34 *Right*
Handbill advertisement for the Leach Pottery, *c.*1927
Holburne Museum and Crafts Study Centre, Bath

THE LEACH POTTERY

St. Ives, Cornwall.          Phone St. Ives 398

Hand-made, Individual and Domestic Stoneware Pottery and Tiles.

Visitors are invited to inspect the works on Saturday mornings and Thursday afternoon. Showrooms are open everyday from 9—5; Saturday, 9—1.

Halsetown buses stop at the Pottery which is ½ mile from the centre of the town on the Zennor-Land's End Road.

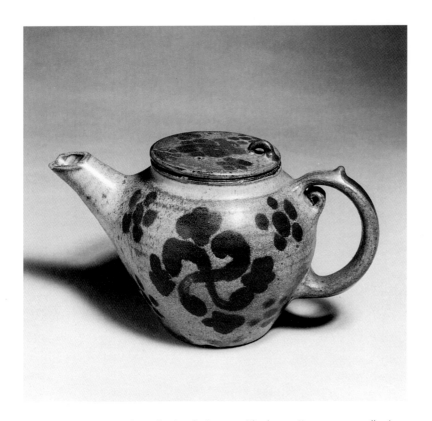

35
Teapot c.1927
Stoneware
H.12.8 cm
York City Art Gallery

impossible to integrate collectors' pieces with domestic ware or collectors with 'the man of small means who desires ordinary household utensils'[25] in one exhibition, he would show the work in two separate places simultaneously. This is precisely what he did in 1927 with exhibitions at both the Three Shields Gallery and the Paterson Gallery. It was the clearest articulation of the dislocation in Leach's art, and met with a mixed reaction. The *Observer* read it as pure expediency. Leach was: 'fortunate … in finding a suitable place of banishment for the more banal products without losing touch with the purchasers whom they might attract.'[26] Charles Marriott, the reviewer in *The Times* took a more charitable line, suggesting that the new domestic pieces showed Leach confronting economic realities head-on: 'he has pushed down the possibilities of the private kiln about as far as they will go to meet the factory on economic terms … Mr Leach cannot produce for less than 5/- a cup and saucer that the factory can produce at 3/-.'

The aesthetic of these 'jugs, teapots, porridge bowls, what not' were adequate enough: 'sensible and friendly in shape and pleasant in colour.'[27] These domestic pieces, for instance the teapot of 1927, are often poorly made and their decoration haphazardly placed, perhaps reflecting the amount of interest Leach actually had in their creation.

The decision to show in two galleries also demonstrates the increasing fluidity of opportunities for a potter. Leach, like William Staite Murray, was able to show at Bond Street exhibitions and to be reviewed in both the art press and in newspapers too. Staite-Murray had exhibited his pots alongside paintings by Christopher Wood and Ben Nicholson in 1928. His work was afforded the status of sculpture in some of the criticism of the day; it seemed

to embody a concern for abstraction in form. A critical language in which to talk about 'this new medium',[28] as Herbert Read called it, was starting to be created. But there was also an increasing number of small galleries dealing spectically in handmade artefacts and catering less for a collecting than for a decorating public. The Little Gallery, for example, would show pots alongside ethnic items from India, and wallpaper designed by Edward Bawden. These exhibitions were not seeking to gain critical exposure: it was the genesis of a distinct 'craft world', and it was a world that Leach, feeling increasingly embattled, was warming to.

Leach was also exploring another new commercial avenue: decorating tiles for fireplaces. This had two great advantages over domestic ware. Firstly, there was little technical problem with tiles being made and fired; and secondly, tiles were an excellent vehicle for his extraordinary facility in brushwork – he could decorate dozens of tiles in an hour. These tiles, fusing together the influences of old Delftware, English medievalism and Oriental brushwork, show Leach in liberated mood. The brushwork is spontaneous and unfussy. The images take wing in an unprecious way – there is no demand for one image to relate to any other and the tiles are untroubled by the necessity to create complex repeat patterns, as for pots. Leach's images are hugely eclectic: English heraldic emblems, Oriental grasses and even the St Ives climbing kiln make an appearance. In the brochure he published to promote them he wrote that the 'tiles have a certain degree of irregularity for which no apology is needed. We are convinced that it is precisely this lack of uniformity, these 'broken' colours, these varying textures that would appeal'.[29] Photographs in the catalogue show 'The Craftsman Fireplace' and oak framed sets of tiles available on request. They would indeed have been 'ideal for a nursery fireplace'.[30] It is revealing that this engagement of graphic skills should have so occupied Leach.

His experience of tile-making also led Leach to think more clearly about the relationship between the art potter and the machine. In a pamphlet entitled *A Potter's Outlook*, published in 1928 by the New Handworker's Gallery, a small co-operatively run London gallery at which Leach exhibited, he articulated his thoughts in the most extended and public way yet. Pamphlets were the chosen form of publication in this bohemian world for addressing the social and ethical implications of handwork. *A Potter's Outlook* was to be the first of his many public forays into the question 'What kind of person is the craftsman of our time?'[31] His thesis was expressed in forceful and vivid language, verging on invective at times. Factories had degraded the folk-art of England and now 'the trade offers us crockery which is cheap, standardised, thin, white, hard and waterproof – good qualities ah – but the shapes are wretched, the colours sharp and harsh, the decoration banal, the quality absent.' And given this moribund state of affairs: 'What have the artist potters been doing all this while? Working by hand to please ourselves as artists first and therefore producing only limited and expensive pieces, we have been supported by collectors, purists, cranks or "arty" people, rather than by the normal man or woman ... and consequently most of our pots have been stillborn: they have not had the breath of reality in them: it has been a game.'

To break out of this attenuated world the artist-craftsman must produce in quantity. This, Leach concluded in Morris-inspired phrasing, meant he must have a knowledge of the machine: 'the machine is an extension of the tool; the tool of the hand ... it is only the *unfaithful* use of machines which we can

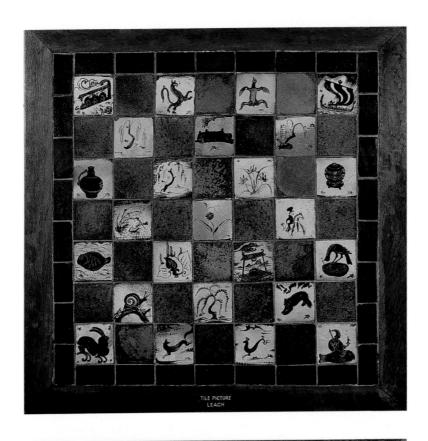

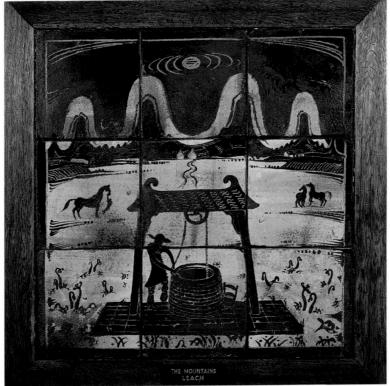

36
Panel of Small Tiles
1929
Stoneware
H.84 cm
York City Art Gallery

37
'Well Head and
Mountains' Panel of
Tiles 1929
Stoneware
H.68.5 cm
York City Art Gallery

attack.' Leach's vision of his future was that of making 'semi-porcelainous stone-ware … I believe it is possible to make household pottery with some of the qualities of the 'Sung' or 'Tang' ware of China – such pots would satisfy the finer taste and practical needs of today'. To this end, he concluded, he was 'changing from wood to oil firing and from hand-grinding to power-grinding and I will put in an electrically driven wheel as soon as I find a silent and efficient one. As far as multiplying production goes – I have only gone as far as having tiles made semi-mechanically – halving the cost – and using the time saved to hand-make stoneware jugs, vases, bowls etc'.

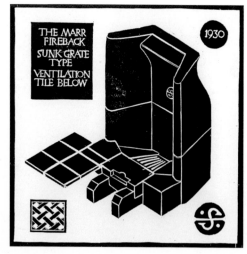

*A Potter's Outlook* shows Leach to be keenly aware of the deficiencies of his position, both philosophically and materially, and desperate of resolution. He was forty years old, with a large family of five children, no financial security and a strong awareness of how well other, metropolitan, art-potters were doing. His desire to make what he vividly called 'necessary pots'[32] was evangelical in its fervour.

The plan was radical, its execution more confused. The lack of a skilled workforce on the Japanese model meant Leach was using a curious collection of ex-students, workers (to whose number his eldest son David was shortly to come) and those he referred to as 'local lads'. Leach held firm views on their respective roles: 'local lads with a half-education – grow up with a normal expectation of pleasure after work which tends to prevent them from really entering a craftsman's life.'[33] The gravitas of vocation was more accessible to those middle class young men and women who, like Ethel Mairet's textile students, 'were under no particular pressure to earn a living'.[34] These students came and went and their skills were partial: 'They come to me year after year from the Royal College, or the Central School, or Camberwell, for longer or shorter, usually shorter, periods of apprenticeship. As soon as they have picked up enough knowledge, or what they think is enough, off they go to start potting on a studio scale for themselves.'[35] Some of those who came to work at the pottery in St Ives chafed at the ad hoc nature of the workshop organisation. Harry Davis, a young and particularly talented potter, complained in letters to the absent Leach that the workshop was 'over staffed' with everyone bored to death and quality going 'to hell'.[36] It is difficult to discern who made what in the St Ives Pottery at this point but one thing is clear: Leach regarded his role as the designer and decorator of the functional wares within the pottery. His Japanese habit of decorating the large exhibition pieces made by others continued whenever possible. 'Necessary pots' were to be made around Leach for the rest of his life. His making of them remained one of more theoretical than practical engagement. But they were to provide him with the platform for his next opportunity to reorganise the relationship between his philosophy and his practice.

Dartington Hall, a fourteenth-century house set amongst formal gardens, parkland and a large estate in South Devon, had been bought in 1925 by an American couple, Dorothy and Leonard Elmhirst. The Elmhirsts had extensive ambitions for their new estate. Leonard Elmhirst had studied agriculture at Cornell University and wanted to implement a new hard-headed scientific approach to an estate he found inefficient and retrogressive. His wife's fortune, as an heiress in the Whitney family, gave them the means to do so. It was to be an experiment in integrating educational idealism, manifested in a progressive school, within a largely depressed rural economy. The estate was to be run as a business, not as a hobby. There was to be intensive battery farming for poultry, hedgerows were to be removed and woodlands planted for timber. The long list of departments on the estate letterpaper runs from Forestry and Sawmilling, Orchards and Cider-House through Textiles to Economics, Laboratory and Draughting. Within this was a place for the crafts, but Elmhirst's ideas were clear: they were to be run as serious economic activities that would bring employment to the locality, as well as educational activities for both the estate workers and the schoolchildren. They were not to be whimsical explorations of ideas, but would be expected to contribute to the larger social ideas of the estate. As Leonard Elmhirst wrote to Leach in 1931: 'We would love it (pottery) to find its natural place as an art, a science and a utility as well as in the educational scheme as an introduction to a sense of form and design.'[37] The Elmhirsts shared with Leach a passion for Oriental aesthetics and mysticism. From the late 1920s they had courted each other, but it was not until the St Ives Pottery was on the verge of complete financial collapse that he agreed to an invitation to come to Dartington to set up a pottery and to teach. The history of Leach at Dartington is a complex one of endless plans, reports and discussions on his role and his future. There were questions as to whether the pottery at St Ives could be run in conjunction with the small workshop established for Leach at Shinner's Bridge on the Dartington Estate. Underpinning this whole period, though, is both the Elmhirsts' unequivocal patronage of Leach as a respected artist coupled with their fearsome clarity about the economics of running a commercial pottery. He was put 'under the microscope'.[38] His ideas and plans were subject to close interrogation.

It was at Dartington that Leach made one of the most significant friendships of his life. Amongst the floating community of *emigré* European artists, dancers and sculptors was the young American artist, Mark Tobey. Tobey was to introduce Leach to the Baha'i faith, and to become a central figure in his continuing attempts to synthesise the spiritual traditions of East and

39
Base of the 'Leaping salmon' vase showing an impressed BL monogram and a St Ives monogram with an incised unidentified thrower's mark
York City Art Gallery

40
'Leaping Salmon' Vase
1931
Stoneware
H.32.7 cm
York City Art Gallery

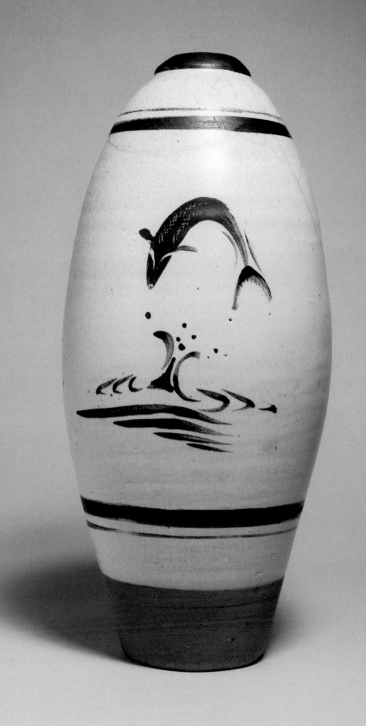

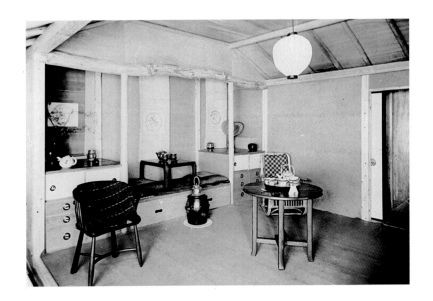

West. Dartington seemed to be the ideal centre for the rural pottery factory that Leach had first mooted in *A Potter's Outlook*. But he stressed the need to experiment to find the suitable prototypes of domestic ware that could be 'manufactured at Dartington in a commercial unit'.[39] He suggested in December 1933, in an application to the Dartington Research Grants Board, that to research this properly he would be compelled to return to Japan. Behind this suggestion lay also his desire to escape his failing marriage. In a revealing comment on his self-imposed isolation, he wrote that in England, he had not the opportunity of comparing notes on technical matters with other potters. In Japan he would have Hamada's expertise, invaluable 'preparatory to starting serious work at Dartington in the direction of making stoneware in larger quantities and finer quality than I have been able to achieve under purely handmade conditions at St Ives'.[40] He would also be able to have contact with the Folkcraft Movement, the 'Mingei' of Yanagi. Leonard Elmhirst approved: 'the fact that you are regarded in Japan as the high priest of this movement is as strong a recommendation for you going as any.'[41]

But there was a pragmatism at root despite this warmth towards Leach's ambitions. The functional pots he contemplated researching and making, described in a later letter as 'The Sung wares, ivory and light celadons … hard and fine and graceful',[42] would have to be truly utilitarian. Leach was told dispassionately that: 'I am particularly anxious to get a couple of dozen cups and saucers with plates to match which I could put in use in the oven to test the wearing qualities.'[43] His 'necessary pots' were to be scrutinised as never before.

Leach was met on his return to Japan in 1934 by a newly published biography of him: a large well illustrated volume full of appreciations and reminiscences by Japanese friends, and reprints of all his earlier articles, edited by Shikiba Ryuzaburo. It was a symbolic start to a year that was to provide a stark contrast to his English life. There were few 'leaders who grasp two cultures' he wrote, and everywhere he went he was accorded the status of a *sensei* or master: 'as to the "sensei" business, apart from being flattering and pleasant to a point, I have no difficulty in accepting the roll [*sic*] when it comes to artistic values and meanings, interpretations and designing capacity − simply because, saving Yanagi, Hamada, Tomimoto and Kawai

41
'European-Japanese sitting room' designed by Bernard Leach and exhibited in Tokyo in 1934
Holburne Museum and Crafts Study Centre, Bath

42
Bernard Leach and Shoji Hamada at Mashiko in 1934
Holburne Museum and Crafts Study Centre, Bath

there are no others who can confidently show and explain the way to this younger generation and to the half-attached world of connoisseurs and art-lovers who are mostly very "boggled" by the complexities of inter-continental art and life.'[44]

Leach was fêted. He lectured on Western art, food and politics. He designed furniture and textiles suitable for a modern living room to be constructed and exhibited in a Tokyo department store. And travelling everywhere in the company of Yanagi, 'I have criticised the local craft work and met the craftsmen and visited their workshops'.[45]

Since Leach had left Japan in 1920 the small metropolitan network of artists and intellectuals with Yanagi at their centre had changed. Where there had been transfixed attention paid to contemporary Western art and ideas there was now an evangelical nationalism. Yanagi's Mingei or 'art of the people' group had burgeoned in the early 1930s in the climate of increasing nationalist fervour. It was now a substantial movement with a monthly illustrated journal, a regional network of associations, patronage from the powerful Tokyo department stores, and annual exhibitions: 'they have their shops and press and sales and their work is on the point of really entering the households of taste of new Japan as an antidote to the wretched half caste and modern products which so sicken Western visitors to this country.'[46]

Its aims were both to preserve some native local traditions of handwork and to revivify others through inspirational contact with artist-craftsmen 'leaders'. There was a distinct class divide involved: the 'leaders' of the movement (Yanagi, Hamada, Kawai) being university and art-school educated, while the recipients of their patronage were peasant handworkers. Leach wrote of this in relation to Hamada: 'Take that tea-cup alone – that handle ... there is only one man in Japan who can put a handle on properly. He knew his own culture before he came to the west to study ours. When he knew both he began to put handles on cups in a way of his own, the real new Japanese way ... Under his guidance a few country potters are beginning to learn and perceive what is needed.'[47]

It is important to remember that this was Leach's first encounter with Japanese country potters rather than the urbane Raku traditions he had come to know before 1920. He was impressed by the sight of a skilled and directed workforce rather than the aesthetics of their work. At Hamada's work-

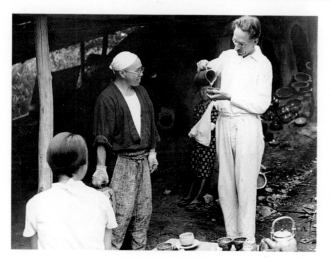

shop in Mashiko 'a young thrower from the village came when required and threw the large pieces under my direction.'[48] At Fujina in the south of Japan quantities of large dishes were thrown for him to decorate with slipware. At Kawai's studio in Kyoto he decorated press-moulded porcelain dishes. Leach was untroubled by money, responsibility or technical problems: the 'greater freedom, more confidence, more inevitability in both drawings and decoration' remarked on by a friend is palpable in his work of this time.[49]

Leach and Yanagi revisited Korea, a Japanese occupied country, on *Mingei* collecting business, 'to preserve some of the exquisite arts of the people'.[50] Leach held a small exhibition at the gallery the Japanese military authorities had allowed Yanagi to establish in Seoul. Leach and Yanagi regarded the occupation with some equanimity: the gallery was a place where Japan and Korea 'could enjoy love of beauty without rivalry or politics'.[51] Their language when talking of Korea – isolation, sadness, loneliness – gave a sense of inevitability to the political situation. The Koreans as measured by their folk-art, were doomed to remain a subjugated people. Indeed this model of a pre-industrial society where inexpensive and simply made functional and decorated domestic objects were the norm seemed to him predicated on a form of oppression. Leach's views of Japanese militarism were similarly straightforward: 'the competition for jobs for young men … is terrific … an outlet is required for these brains greater than Japan proper offers. China across the water remains lethargic and disorganised for lack of just what Japan has a surplus of.'[52] His analysis of Japan's 'abounding vitality' and 'national confidence' was shaped by his experience at the heart of the *Mingei* movement: the one he felt to be mirrored in the other. Returning to England he wrote that he too had 'gained in confidence'.

During 1934 whilst in Japan, Leach's eldest son David had elected to study in Stoke-on-Trent with the Elmhirst's support. The realisation of the desperate need to put the St Ives pottery on a secure technical footing had led to this but Leach had bitterly attacked this decision to send David to 'that commercial scientific graveyard. It will do him more essential harm than good'.[53] The anticipated lure of study in Japan or Denmark for David was firmly squashed: 'with some justice David argues that it would be difficult to get the elements of a science either in Danish or in Japanese', wrote Leonard Elmhirst.[54] Leach's fury showed just how radically different were their attitudes to resolving the questions of 'appropriate' technical means to ensure consistent production.

On his return to England in 1935 Leach did not settle again in St Ives but eventually moved to Dartington with his secretary and future second wife Laurie Cookes. With the St Ives studio being run efficiently by David, Leach was now principally engaged in writing his book on pottery making, a book dreamt of since 1920. It was intended as both a technical guide and an aesthetic one: the student and the collector were to be led through each stage of making in a concise way and informed of the aesthetic judgements needed at each point. As his editor he had Henry Bergen, a supportive academic friend and collector of studio pottery. The shape of the book is due in great measure to Bergen's fierce interventions. Leach was told to keep his ideas on social reform back, to cut autobiographical reflection, to avoid rhetorical sweeps, 'cackle and prancing'. Leach's

43 *Right*
Dish 1936
Stoneware
Diam.25.5 cm
Leicester City Museums

44
The title page of
*A Potter's Book*
by Bernard Leach

A POTTER'S BOOK

*by*

BERNARD LEACH

*with Introductions by*

SOYETSU YANAGI
*and*
MICHAEL CARDEW

FABER AND FABER
*3 Queen Square*
*London*

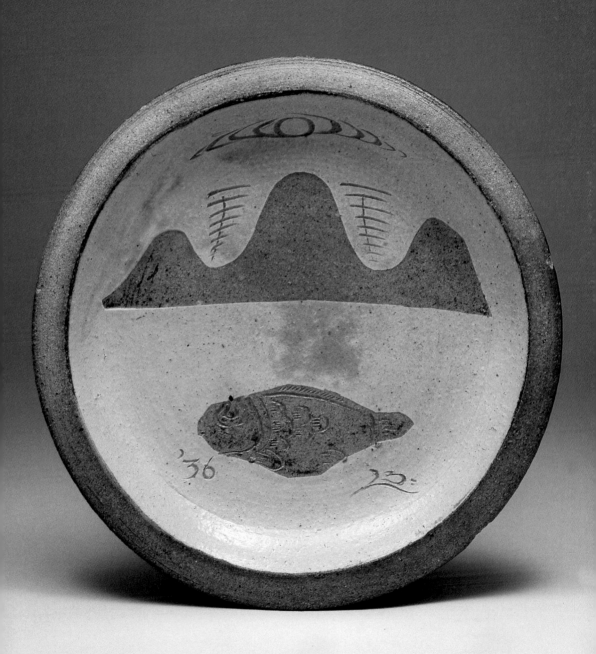

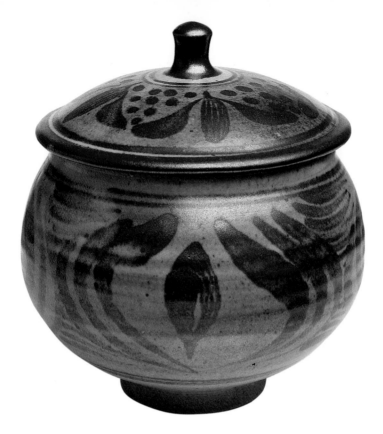

45
Jar c.1936–9
Stoneware
H.18 cm

The Wingfield Digby
Collection

strictures on industrial production were severely trimmed and he was told to read Herbert Read and Nicholas Pevsner on subjects about which he knew little. According to Bergen, the model for his book was to be more like Edward Johnston's book on calligraphy, *Writing, Illuminating & Lettering*, than a social tract: it should be lucid, 'a manual not a polemic'.[55]

*A Potter's Book*, finally published at the start of the war in May 1940, stands as both manual and polemic. Indeed its significance and popularity are due to the complex way in which Leach's technical descriptions are bound up in his values. It is a book that seems to encode the whole meaning of being a potter and working as a potter, not simply the making of pots. From his introductory chapter, 'Towards a Standard', through the technical chapters to the description of an imagined month in the workshop life of a potter, Leach rehearses his convictions about the place of handwork in society. The photographs are of his canonical pots, Sung jars, tea-ceremony bowls, works by his friends and himself. It appears a seamless book, self-confident in tone and magisterial in reach. Its subsequent status as 'the Potter's Bible' is due to its powerfully hieratic nature.

Leach starts from the presumption that there is a need for a common standard of 'fitness and beauty' and that such a standard is lacking in the West, where the appreciation of pottery is a marginal activity. In a culture where 'bad forms and banal, debased, pretentious decoration' is the norm the studio potter is 'constrained' to look to the East and 'accept the Sung standard without hesitation. As it is there are a few English craftsmen potters today who do accept it, and their work is incomparably the best that is now being turned out'.[56] This 'Sung standard' meant an acceptance of natural materials, of simplicity and spontaneity in throwing and a 'subordination of all attempts

at technical cleverness to straightforward, unselfconscious workmanship.' This was the apotheosis of Sung wares. Leach ascribes to them all the values absent in the West: 'an unprejudiced survey of pre-industrial pottery, especially Far Eastern, must lead to the conclusion either that its makers were first class bunglers or that we have got our values upside down.'[57] They stand as a marker against the Western work cursed by 'over-accentuated individualism' and intellect. Some intuitive peasant craftsmen in the West could hold out against this tide but even their 'horse sense and creative vigour' was ultimately doomed. Leach tells it as a compelling story; examples, distractions, details are swept aside in the fervent narrative. His self-confidence in the diagnosis of the place of the individual potter within this moribund Western society is total. His judgements are expressed as absolutes: 'a pot in order to be good should be a genuine expression of life', 'it is true that pots exist which are useful and not beautiful and others that are beautiful and impractical, but neither of these extremes can be considered normal: the normal is a balanced combination of the two.'

The book is shot through with Leach's ideas of appropriateness. Glazes should have the qualities of melted stone, forms should not be imitative of other materials but be 'true to clay'. Potters too should have a Sung standard, a modesty in their work's objective, and in the manner in which they work. It is hard work, he stresses, but such work is redemptive: the finished pots will reflect the rigour of their making. He compares this with the 'dilettantism of young people who imagine that they can play at potters, condescending in their opinion from fine art to a craft'.[58] There is a whiff of the Victorian Samuel Smiles' popular manual of self-improvement *Self-Help* in the book. The gravity of the vocation of being a potter emerges: the potter must be symbolically independent of contemporary society. Many of the reviewers were complementary, but some pointed out that Leach's canon of pots left out great swathes of ceramic history. Almost all ceramic sculpture was disregarded. Faience and other kinds of European decorated wares were disparaged; his forerunners in the French stoneware studio pottery movement reviled. A reviewer in the *Burlington Magazine* wrote: 'He pronounces judgement with an almost arrogant dogmatism, and this is hardly made more impressive by a knowledge of ceramic history which is, to say the least, somewhat defective.'[59] Leach's dismissal of Italian majolica as 'weak and ornate' brought the rebuke that 'some of the author's aesthetic judgements may scarcely command universal acceptance'.[60] His authoritative tone was remarked on too: it seemed to smack of exclusiveness. 'Thus is formulated a new academicism. Not only are many other sorts of past ceramic achievements dismissed by it as debased or at best misguided, but the future is closed. It will admit only hand made ware of the kind produced by the author ... for a precarious market of rich and cultured people, and those few commercially produced wares that illogically conform to the same standard.'[61] Herbert Read, whilst generally admiring the book, made the point that 'Art is various – even the art of pottery'.[62] The gravitas of Leach's book, though, lay in the feeling that art was not various but very particular indeed. It was the very absoluteness of Leach's 'Sung standards', 'the ethical pot', that were to define the post-war agenda on ceramics.

# 3
# The Need for Roots
# 1940–1979

The Second World War acted as a catalyst for Leach's attitudes to making pots. The demand for collector's pots disappeared and the mood and the conditions of war 'to some extent caused us to change course. The relative demands of necessity won the argument, and we began to make more of the standard ware which we introduced before the war. I made the prototypes, drew them on cards with measurements attached, and these were handed out to whoever was making cups, saucers, beakers, bowls, jugs etc. Naturally the price of our plain household pots was less than for those we had supplied to art galleries, so we had to take steps to increase production … It preserves a useful connection with the demands of life itself'.[1]

With factories engaged in essential war-work, Leach pitched his idea of 'necessary pots' to the authorities, and won the right to employ conscientious objectors as well as local labour. The painter Patrick Heron was one of those who staffed the pottery. Leach could argue that the pottery was making genuine 'utility ware'. And like the pioneer furniture designer Gordon Russell was to do, he could use the ideas and image of utility to advantage. Russell wrote: 'the basic rightness of contemporary design won the day, for there wasn't enough timber for bulbous legs or enough labour for even the cheapest carving and straightforward, commonsense lines were both efficient and economical.'[2] 'Utility', in pots as in furniture, was expressed through using materials in their most unadorned state, and in the lack of disguise in the method of their construction. Leach called these new category of pots 'standard ware'. The phrase is a rich one: resonant not only of work being commonly available and having continuity, of being ordinary, but also of his standards: propriety, integrity, authority. The Sung standard set out so forcefully in *A Potter's Book* was made palpable within standard ware. The shapes were sturdily thrown in stoneware. This meant that the exteriors of the pots could be left unglazed to give a toasted golden-brown colour to contrast with the interior glazes. Decoration was minimal, an occasional calligraphic three brush-strokes forming a 'zed' on the sides of some bowls, more a cipher of decoration than decoration itself. The palette of colours was straightforwardly oriental (celadon grey-green, tenmoku black-brown and cream oatmeal), the forms mostly of a more indeterminate Western character. But just as Gordon Russell called his furniture after areas of the country (the Utility Cotswold armchair for instance), so some of Leach's standard ware pots self-consciously embody Englishness. He made beer tankards, which retain their Cornish antecedents, six different kinds of jugs, two different sizes of beer-tankards, cake-dishes, porringers and egg-bakers, and even a lidded butter-ration pot. The ad hoc days had gone: the catalogue which accompanied the standard ware revealed a secure technical basis to the workshop

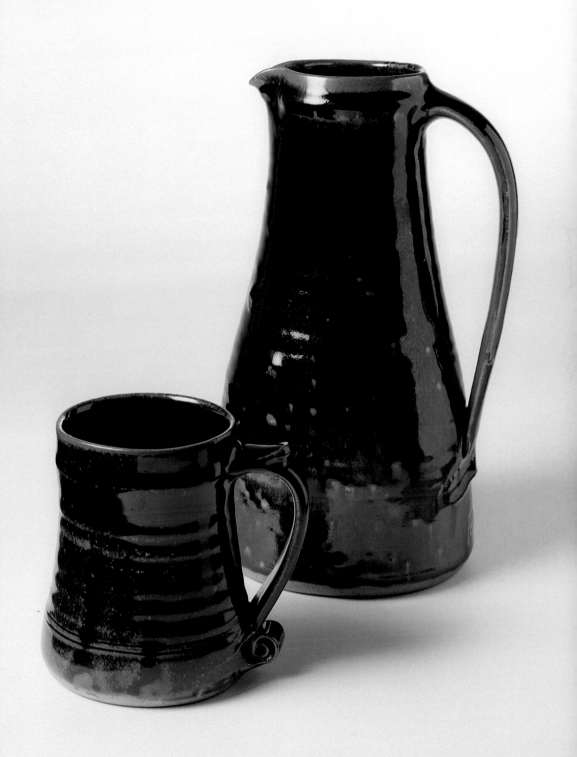

and a considerably more pragmatic attitude to selling. The substantial work that David Leach had done to establish the efficiency of the workshop now began to pay dividends. These 'standard' pots had the St Ives seal impressed into their bases: those that Leach had made also received the BL seal-mark in addition.

There was a new momentum to the workshop: here was an identifiable way of training and using students, a standard to which they could be measured. What, before the war, had been unstructured now became a more formulated process of teaching. Leach, with the image of a Japanese workforce still strong, wrote: 'the employment of simplest types of local labour may modify but does not squarely face the issue because we can no longer return to the productive unconsciousness of country traditions … those who are attracted to hand craft are no longer simple-minded peasants but mainly conscious art-students anxious to establish their own workshops at the earliest opportunity.'[3] The social hierarchy of Leach's workshop is explicit here. Local lads were equipped with what he called 'horse sense': they were useful and productive labour but not of the same vocational order as the art students. His reliance on these 'local lads', in particular William Marshall, who was apprenticed in 1938 and worked at the Leach pottery until he set up his own studio in 1977, was enormous. Marshall, an extremely talented potter, threw the majority of the large pots that Leach decorated after the war. But, just as Cardew and Mairet used 'productive' local labour to provide an economic backbone for their own individual work, Leach continually emphasised the social and artistic striations of craftsmanship. It was a vocational activity for middle-class self-conscious art-students but only labour for the unselfconscious locals. And while the art-students should, paradoxically, aspire to the condition of the locals, Leach didn't perceive any possibility of the reverse happening. 'High-collar' workers were to be avoided. The image that he invokes in his writings is that of musicians: 'a small orchestra under a willingly-accepted composer-conductor.'

There were also gradations within vocational activity. Of one of his art-students, he wrote: 'she did not become an individual potter any more than a good cellist becomes necessarily a composer.' His standard ware was, to use his own terms, a musical score to be interpreted only under his direction; to aspire beyond sound musicianship was by implication to aspire beyond your social class.

During the war Leach became ever more actively involved with the politics of the craft world. With Staite-Murray caught by the outbreak of war in Rhodesia and unable to return and Cardew opting to work in East Africa, Leach was the most prominent potter left in England. He was instrumental in helping choose pottery for a 1942 Exhibition of Modern British Crafts to tour America and joined the committee that regularly met in London to plot the

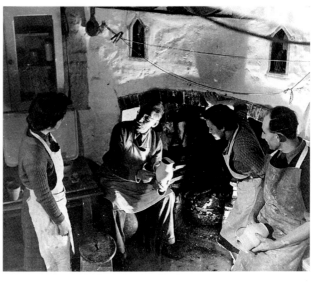

47
Bernard Leach, David Leach and students at St Ives, c.1949
Holburne Museum and Crafts Study Centre, Bath

course of a central crafts body for the post-war period: 'in the period of re-construction which will follow the war: we will have a possibility of achieving for craftsmanship its true place in a modern country'.[6]

As the disparate and fragmented craft world of guilds and craft societies became more centralised and started to receive tacit government approval for the first time, Leach was omnipresent, 'intimately connected with the politics of craft'.[7]

In exhibitions, and in such pamphlets as Charles Marriott's *British Handicrafts* of 1943, the crafts were displayed as an essential reflection of irreducible British character. The first substantial post-war exhibition of design and craft, 'Britain Can Make It', played on the war-time slogan 'Britain Can Take It', linking the nexus of making and national identity firmly together. 'Making It' in this context was not Leach's art pottery but pottery as a craft with high social utility. Pottery seemed to be an activity of unambiguous purpose, to fit within a newly ordered society. Many of the people who came to work at St Ives or who were already influenced by *A Potter's Book* and had become potters, had been in the war. Leach recounted that: 'These people came out of the bitter destructive experience of the war. How many times whilst travelling to and from London for national craft committees, during long night hours in overcrowded trains, did I hear men in the Forces say, 'When this —— show is over I will never go back to the old job: I want to do a job I can enjoy'.[8]

In the first substantial book on studio pottery to be published after the war, *The Work of the Modern Potter in England,* George Wingfield Digby, an enthusiastic collector of Leach's work, wrote of this yearning for creative work: 'now after the Second World War its voice is more insistent that ever. Here, in modern pottery, it can find a healthy outlet and means of expression. These impulses are at the root of this movement and give it virility and life.'[9]

A large jar with handle of this period shows Leach using the ideas of utility and of Englishness to effect. It is based on the style of English mead jars with a large round seal of an indeterminate medieval character. It would be impossible to use with any comfort, but its identity is caught up with the image of abundance and plenitude. Leach was to write on medieval jugs in slightly arch terms in his book of 1951 *A Potter's Portfolio*: 'How this jug does sit inviting a grasp of its admirable handle to pour out a refreshing drink of bitter English beer! And as fine as the best of brews is the balance of form, hard and soft, thin ridge and round lip.'[10]

His mead jars, stem cups and jugs made around the time of the Festival of Britain share this slightly self-conscious air of celebration of Englishness. They fit with the mood of almost jocular historicism that pervaded Hugh Casson's designs. Leach exhibited his standard ware in the Festival's Country Pavilions and more individual pots in 'The British Craftsman' and 'Nature' at the Lion and Unicorn Pavilion both on the South Bank. Importantly, in the Rural Crafts section, the majority of the potters exhibited had been taught by Leach: his influence was more discernible here than ever before.

Later that year a World Craft Conference was held at Dartington Hall. The agenda was so dominated by Leach's presence that the question 'to Leach or not to Leach' was asked.[11] 'This conference is, I think, Bernard Leach's dream', was the opening statement.[12] The agenda of the thirty six lectures, demonstrations and discussions was largely shaped by Leach's definition of the craft world: the polarity between the East and West, though there were wide-

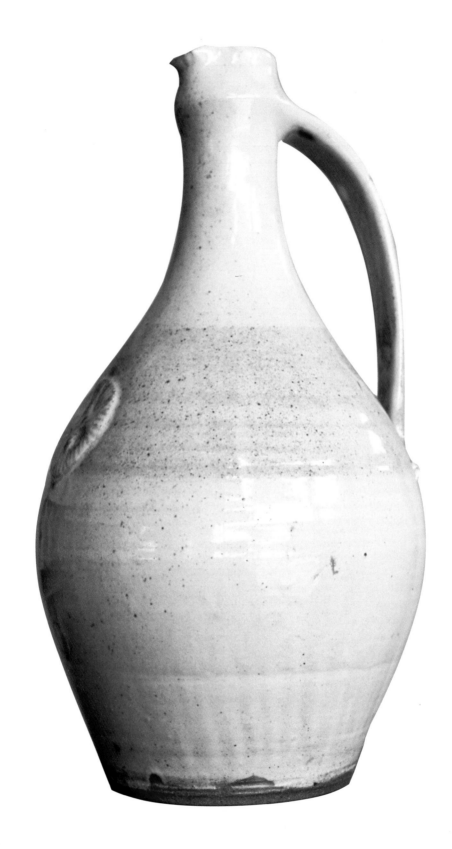

ranging lectures on education and material science, on Scandinavian ceramics and the Swiss folkcraft movement. The concerns of contemporary craftsmen, Leach lectured, are 'the discovery of what the roots are',[13] roots not discernible in Europe or America but in Japan and England, 'two countries, protected by a band of water … the repositories of the cultural context of the continent behind'. With Hamada demonstrating and Yanagi lecturing on Japanese aesthetics, Leach defined his position as: 'a kind of link or courier between English and Japanese potters in the interchange between our pre-industrial traditions and theirs'.

He was, by implication, the linchpin in the discourse of what crafts were about. The other discourses, whether scientific in the case of a lecture by Cardew or aesthetic as in a lecture by Patrick Heron on contemporary art, were marginal to his assumption of the role of explicator and revealer of a cultural and spiritual polarity that only he and Yanagi could bridge.

The exhibition held concurrently with the conference, subsequently moving to the New Burlington Galleries in London, was equally dominated by Leach's taste. Historical pots fell into only three canonical categories: medieval English; eighteenth-century slipware; and Oriental stoneware. Leach's and Hamada's pots were shown in the greatest quantity. Due to their preponderance, the works of Lucie Rie and Hans Coper were thrown into even greater relief, one reviewer commentating: 'the general effect is of an ethnographical exhibit of the remains of a lost civilisation, of a village and market town community of highly aesthetic peasants … Only the stoneware of Hans Coper and the porcelain of Lucie Rie remains outside the prevailing atmosphere of rural quietism … They alone make the point that the whole exhibi-

**48**
Large Jar with Handle
1946
Stoneware
H.39 cm
The British Council

**49**
Soetsu Yanagi,
Bernard Leach
and Shoji Hamada
at the Dartington
Conference in 1952
Holburne Museum and
Crafts Study Centre, Bath

tion was intended to make. They show that the artist-craftsman is not necessarily an anachronism in our time, that it is not impossible to him or her to be, so to speak, with us.' It is a revealing review, standing as one of the first indications of an alternative aesthetic and of a division between anachronistic, rural potters and contemporary urban style.

As Leach's influence as a teacher of potters through the expanding workshop training and through *A Potter's Book* increased, for the first time it became possible to talk of a 'Leach style'. Leach's 'quietist' palette of glaze colours and his minimal calligraphic decoration were adopted by many of the new country potteries established in the 1950s. 'Necessary pots' were passing from the rarefied and cultic (hard-to-find, of a technically doubtful quality and often expensive) into the mainstream of a culture increasingly interested in the cooking traditions of peasant cultures. Elizabeth David's cookery books and the popularity of ground coffee are intricately linked into the phenomenon of pottery casseroles and pottery mugs. There is an elective austerity in 'simple' pots and scrubbed pine tables, indicative not only of greater wealth

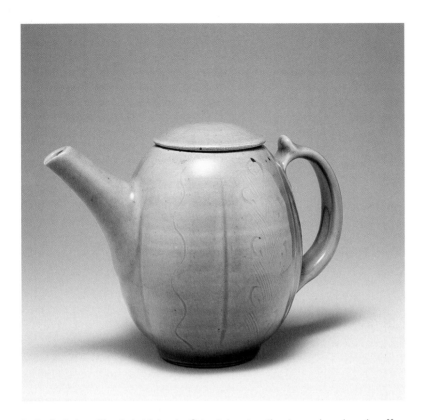

but of choice. The hybrid Anglo-Oriental pot – the tenmoku glazed coffee mug or celadon casserole – were increasingly distant from any progenitors. The Leach style was so ubiquitous that Leach's own lengthy and problematic process of integration was overlooked. Leach pots were becoming a new kind of 'standard' pots.

However, as the reviewer of the 1952 Dartington exhibition implied, there were other kinds of pottery being made that had little connection with Leach's aesthetic. This had always been the case, but whereas Leach in the 1920s and 1930s had occupied an equivocal place between art and craft, he was now powerfully entrenched in the new post-war craft world which he had been so instrumental in creating. The new art school ceramics were connected with worlds with which Leach had no contact. For example a number of students, including William Newland, Nicolas Vergette and Margaret Hine from the Central School of Arts and Crafts, were making work of startling originality. They owed nothing to Leach's canon, his 'only possible yardstick' of pots; their work looked towards the Mediterranean, attenuated Cretan forms, Minoan sculpture and lavish colours were part of their world. This was the earthenware tradition, dismissed in *A Potter's Book*, brought to an abundant life. The forms are indicative of where they sold: narrow canapé dishes, expresso cups, wall pieces, 'necessary' in strictly metropolitan terms. Their most obvious influence was Picasso, whose ceramic work was just then being seen for the first time. Leach's derisive name for the group, 'the Picassettes', summed up his attitude to this work and to its makers. Of Picasso he wrote: 'great acrobat that he is, I cannot call him a potter'. What annoyed him was their 'acrobatic' quality. It was eclectic rather than commonsense, showing off rather than modest, and above all, unnecessarily colourful.

50
Teapot 1952
Stoneware
H.14 cm
High Cross House,
Dartington Hall

51
Illustration from
a Leach Pottery
standard-ware
catalogue from 1955

63    21    64    4    3

82    15    14    13    10

81    32    11

1    19    57

2    58    83

54    28    55

77    9    73

78    84    37

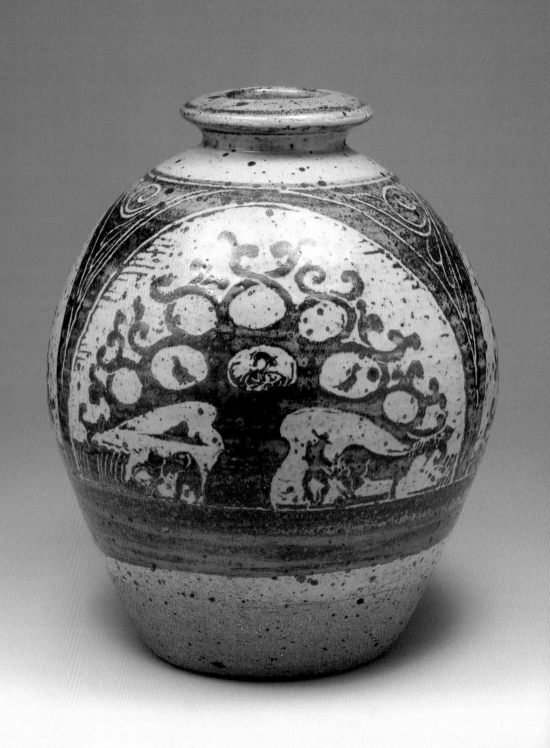

He was to say of the young American potters he encountered: 'would they have been any better able to find themselves in their quiet roots without him? There is the gist of the modern problem – to find one's quiet root.'[15]

Leach's experiences as he resumed his travels affirmed this view. His travels in the 1950s and 1960s were extensive, a result of his growing popular fame. His analysis of American pottery remained true to his constant re-assertion of: 'thankfulness that I had been born in an old culture. For the first time I realised how much unconscious support it still gives to the modern craftsman. The sap still flows from a tap root deep in the soil of the past, giving the sense of form, pattern and colour below the level of intellectualiza-tion. Americans have the disadvantage of having many roots, but no tap-root, which is almost the equivalent of no root at all. Hence American pots follow many undigested fashions.'[16]

This critique met with mixed responses. It was pointed out that Leach had diminished the American Indian traditions (they 'do not proceed on individual choice and the root in their case is the race-root') and ignored the country traditions of the Carolina potters as being an authentic tradition on which to draw. As Marguerite Wildenhain, a noted American potter and educationalist, wrote, 'Roots are, of course, useful to have, but who has the one, single "tap-root" you talked of. That single tap-root no longer exists in our day. It is prob-able that it never existed'. She suggested that Leach was unable to see other kinds of pottery: 'It ought to be clear that American potters cannot possibly grow roots by imitating Sung pottery or by copying the way of life of the rural population of Japan. Conscious copying of the works of a culture unrelated to the mind and soul of our generation would only produce dubious makeshifts and turn our struggling potters into either dilettantes or pure fakes.'[17]

Other Americans saw Leach and 'his constant harping on our lack of cul-tural roots' as symptomatic of a form of colonisation, one commenting that, though a great writer, 'his pots are … disappointing: stuffy, heavy and mid-Victorian … His pots show that honest, solid quality which is so "veddie, veddie" English; and incredibly dull'.[18]

The question of a 'Leach style' led to an increasing perception that Leach's own work and his influence were becoming difficult to differentiate. There were by the late 1950s so many potters who had trained in his workshop and set up abroad making pots in a similar manner that a reviewer of an exhibition in New Zealand in 1959 could remark on 'the preponderate influence of Bernard Leach in the work displayed. So much so that the derivative nature of much of the form speaks of over-much dependence. It is here, sadly enough, that the colonial spirit of self-reliance is weakest and thinnest … the weakening influence of Oriental stoneware is in danger of becoming the aca-demicism of New Zealand craft pottery'.[19]

Leach was, in effect, being accused of academicism himself: of producing a conventional series of forms against which all forms of pottery should be measured. His 'standard' was seen as an ossified and monolithic benchmark, unable to take account of developing conditions or differing cultures. His cer-tainties, expressed in Blakean aphorisms as a young man, and now as in-creasingly moral apophthegms seemed distanced from a younger generation. He was now in his seventies, and his self-definition as a pioneer artist-craftsman left him with few peers, aside from Hamada, to accompany him as he grew into his authoritative role as the grand old man of potters.

The large jars of this period have become known as Leach's most characteristic work. Standing up to two feet tall they have a scale and a sense of expansiveness that he had only achieved before the war with his slipware chargers. Their success is partly due to a developing simplicity in decoration. They were glazed in either tenmoku or a mottled ash glaze they rely for effect on direct handling in decoration: applied sprigs of clay in one case or strong vertical fluting in another. His reliance on complex imagery (trees of life, wellheads and so on) to encode the significance of the pot, became less as the forms and glazes themselves accreted yet more meaning. Leach knew that a particular jar form or glaze could say 'Sung' or 'Medieval English' to his audience without him having to explain. But their success is due in great part to the quality and facility of the throwing: William Marshall often threw the pot to Leach's designs leaving only the neck to be finished by Leach. There are ironies implicit in the fact that some of Leach's most memorable works were not actually made by him: the paradoxes of their 'authorship' have been consistently overlooked.

Leach spent almost two years in Japan from 1953 to 1954. It was a journey that, like his visit in 1934, was to provide him with a renewed sense of his role as an authoritative guardian of essential values. His journals were to be published later as the vivid travelogue *A Potter in Japan*. They describe his travels, again in the company of Yanagi, Hamada and Kawai. Leach was met by highly respectful devotees: the rounds of meetings, lectures, radio-broadcasts and exhibitions was constant, with his views endlessly solicited and affirmed. The contrasts in what he saw were marked: he found Japan a country degraded both by defeat in the Second World War and by industrialisation, yet with a vigorous *Mingei* movement with status and evident ambition. As the pre-war polarisation between the rapid growth of industry and remaining folkcraft traditions had gained in intensity there were now new problems to address. Leach anatomised the situation: 'First, there were far too many would-be craftsmen, second, that there were too many others working in the manner of folk-craftsmen when they were no longer anything of the sort.'[20] This analysis seemed better received in Japan than in America. Dissension was rare and rather startling:

53
Detail of the base of the large jar (see fig.54)

54
Large Jar 1960
Stoneware
H.31 cm
Buckinghamshire County Museum

A young 'individual' potter protested that our advice to stick to good old traditions was cramping. Yanagi and I, each in our own way, replied: 'Be modest, these results of wild experiment show indigestion, launch out into new only as you can understand it and feel it, in any case only a few have this natural creative capacity in my country.'[21]

Leach seemed particularly dismayed by finding 'nearly everywhere … a half-digested influence from Hamada or Tomimoto or even from myself.'[22] During an extended period making pots in the remote village of Onda he saw this process happen in an immediate way. By the end of his stay he found 'my shapes and even patterns have been copied in every workshop. I found my children everywhere dressed in ill-fitting garments'. At the annual *Mingei*

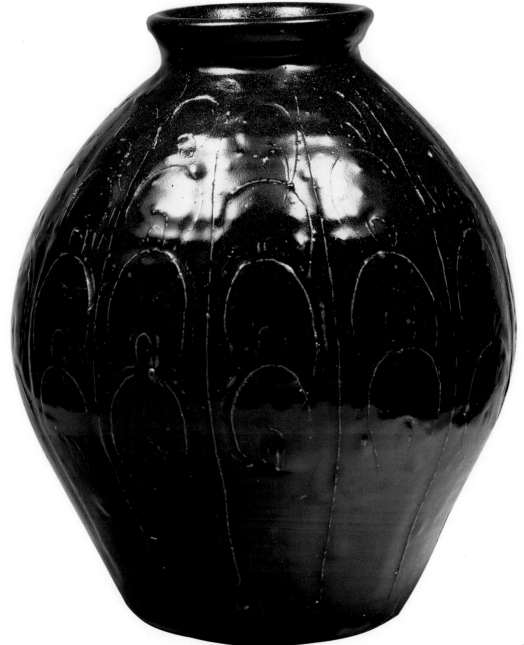

meeting he raised 'the problem of the copying by traditional craftsmen of designs by individual potters ... A few agreed with my protest, but Kawai jumped up and challenged me to say that my designs, or any other artist-craftsmen for that matter, belonged to me or to them in any sense of exclusive possession.'[23] Leach described himself as 'somewhat taken aback by Kawai's protest, and to avoid public dissension, did not pursue the argument',[24] except to point out that the copies were not successful. But his identification of the difference between influence and copying seemed to be predicated on the social class of the perpetrators as much as by outcome. He wrote after his experiences that it was, 'obvious that the assimilative capacity of the far less articulate communities like Onda and Fremington [in North Devon] has waned and requires new props'.[25] The inference is quite clear: that it is the responsibility of leaders like Leach himself to influence directly the traditional craftsmen ('keen and intelligent in a countrified way'[26]) who are otherwise in danger of being lured into direct, unsupervised copying. The fundementals of his analysis of how craftsmanship evolves had not changed since his first encounters with the carpenters of Abiko in 1918.

Leach made three distinct bodies of work during his Japanese visit. In Onda he worked in a country tradition making jugs, jars and decorating large chargers thrown for him. In Kutani, one of the great porcelain centres, he made use of overglaze enamels and in Mashiko worked with Hamada's clay and glazes. Once again Leach exploited to the full the rich decorative possibilities offered to him by these three opportunities. The decorating of the square porcelain dishes made at Kutani, for instance, have a quality of immediacy not unlike his pen and ink drawings that were a constant of his Japanese journeys. There is a similar abbreviation of gesture: it is as if Leach was so at home within the vocabulary of the Japanese imagery that his fluency of brushwork increased. There is almost a solipsism at work, a sense that he did not have to explain the images he used.

A subsequent Japanese journey in 1961 also saw the start of Leach's ill-fated attempt to reassess the Kenzan tradition to which he was indebted as holder of the title Kenzan VII. Leach was aware of the difficulties of this: 'this undertaking is really beyond my training and natural capacity, particularly as I cannot read Japanese texts', he wrote candidly.[27] Indeed he used Ernest Fenollosa's writings, published before the First World War, to help his research. But though he was well aware of the fact that 'the number of faked Kenzans knocking about the world is astonishing',[28] he became embroiled in what was to become known as the 'Sano-Kenzan scandal', a scandal that exposed the limitations of Leach's knowledge of the Japanese art world. Leach had written a substantial amount of a book on the Kenzan tradition when he was invited by a former student to view an unprecedented find: 120 pieces of Kenzan's pottery had come to light along with three journals full of the images used on the pots. This appeared to be a late and vivid flowering of work by an elderly Kenzan working in the provincial district of Sano that had somehow been forgotten. Tomimoto kept his distance but for Leach he was 'repaying a debt of obligation',[29] and was soon at the heart of the debate. For him it was a 'ludicrous' idea that they could be recent fakes. The objection that both 'the writing and painting ... is not that of an old man of seventy-five does not hold much water ... I who am seventy-nine have not got shaky yet'.[30] His book, Kenzan, reads as an argument with his Japanese critics purely on aesthetic grounds. Now universally held to be fakes Leach's espousal of this work

55
'Pilgrim' Dish 1962
Stoneware
Diam.32 cm
Leicester City Museums

64

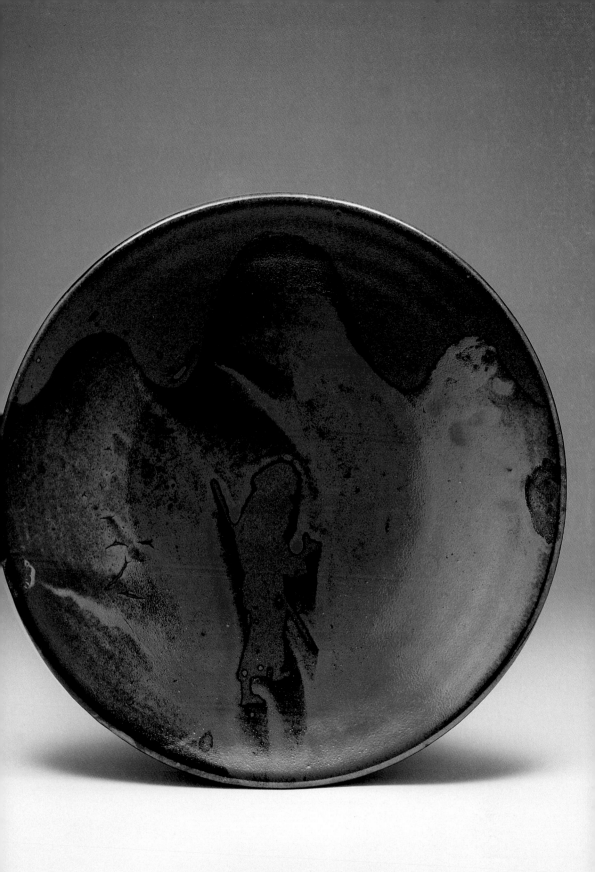

in the teeth of the opposition must be seen primarily as a fierce identification with Kenzan himself. 'I feel that I am fighting for old Kenzan', he wrote in a letter.[31] But it also shows Leach adrift in a Japan outside the *mingei* world of friends and admirers, and in a world where his own knowledge of Japanese art was so mediated through translators and intermediaries that he was able to become implicated in a palpable fraud.

In the latter part of his life, writing on pottery was to become increasingly significant for Leach. Alongside extended periods of travelling and exhibiting in America, Japan and Australia, he was to publish a series of diverse and popular books. Amongst these were his Japanese travelogue *A Potter in Japan*, his book on Kenzan, his compilation of writings by Yanagi, *The Unknown Craftsman*, a book on Hamada, a photographic essay of 'inspiring pots' *A Potter's Challenge,* as well as a miscellany of memoirs and poetry *Beyond East and West.* That he was able to do all this was an indicator of the success and momentum of the St Ives workshop. Both his sons David and Michael had left to start their own potteries, leaving behind a training system and established technical knowledge that meant the workshop functioned both efficiently and profitably. Many potters were now benefiting from a training system that was clearly constructed, and the 'standard ware' was being made in substantial quantities. He had met the American potter Janet Darnell on his first visit to America. On his 1954 trip to Japan they met again and were married. Janet Leach now ran the workshop alongside making her own pots, leaving Leach freer than ever before to philosophise about pottery.

In much of these later writings autobiography cedes into philosophical rumination. His own life story and pottery-making itself meld together seamlessly. There is a pull towards the mythic at work, stories told and retold of how he started to make pots, of pioneering years and of pioneering friends. 'The debt of obligation' that was his book on Kenzan, is also a reasonable description of his book on Hamada, 'a pleasant rambling book of reminiscences of two elderly potters compiled … from tape recorded discussions in a Tokyo hotel room'.[32] In Leach's editing of Yanagi's writings into the book *An Unknown Craftsman* the sense of indebtedness is powerful. It is a book that pulls together reminiscences, interviews, edited essays and adapted texts with photographs of *mingei* artefacts and Hamada's pots. It acts both as an apologia for the *mingei* movement to the West and as an Oriental confirmation of Leach himself. The concepts of self-surrender and humility within craft practice that had become a constant of his philosophy now had proper validation. None of these three books are exactly explications of Oriental aesthetics in the manner of parts of *A Potter's Book.* They are more reiteration of disclosed truths than interpretative texts. As he was to write in the preface to his book of poetry, *Drawings, Verse and Belief,* 'I feel I have … a message to deliver concerning something much more important than myself and my shortcomings. I mean the beliefs, the arts and their successful cultural interplay between the two hemispheres'.[33] Long fêted by Japanese and English friends as a conduit between two cultures, Leach, in old age, becomes increasingly prophetic, writing on the final page of his collection of autobiographical writings *Beyond East and West*: 'I have seen a vision of the marriage of East and West, and far off down the Halls of Time I heard the echo of a child-like voice. How long? How long? "Farewell".'

A review of his memoirs talked disparagingly of these excursions into cultural criticism: 'his philosophical ruminations (which, alas, have none of the

56
Fluted Bowl 1960
Porcelain
Diam.23 cm
Buckinghamshire County
Museum

cleanness and clearness of his pots or his descriptive writings).'[34] But this kind of philosophical ambition is also discernible in some of his later pots. For instance, he made a series of 'Pilgrim dishes' in which a figure with a staff is seen against a background of hills, and the 'Tree of Life' motif used throughout his life becomes even more stylised. But amongst his final pots there is a core of exceptional pieces made against a backdrop of his failing eyesight and decreasing strength. These are his porcelain bowls and vases, often thickly thrown by Leach himself, and with the rapidly incised or fluted decoration that he had often referred to in Sung pots: 'the stroke is done with one movement which may be either vertical or slanted, and there are no stops, no corrections – done with the tongue between the teeth.'[35] Part of their accomplishment lies in the haphazard quality of these fluted lines, an unstudied interaction with the surface of the pot that gives a sense of the plasticity of the clay itself. Leach's throwing almost became more expressive as his technical facility decreased. These are pieces that are small in scale and they have little sense of public utterance, unlike his large ambitious tenmoku-glazed works of the previous decade. They have a lyricism that puts them amongst the very greatest of his works.

In 1977 when Leach had reached the age of ninety, the Victoria and Albert Museum held a retrospective of his pots and graphic work. The consensus amongst the reviewers was just how interesting the connections were between Leach the potter and Leach the artist on paper. Seeing the pots in a museum in glass cases no longer surprised anyone, indeed Leach's apotheosis as the 'grand old man of pottery' was widely welcomed within the art world as well as within the pottery community. But whilst it seemed acceptable to regard pots as art-objects, the 'atmosphere of moral regeneration which surrounds the work of Bernard Leach'[36] was seen as a positive hindrance to the examination of his pots. To look at Leach's pots was now almost impossible without being simultaneously aware of all his school of conscientious and meretricious followers.

For the last years of his life Leach was blind. He concentrated his still great energy into his religious writings, leaving the running of the pottery to Janet Leach. She reassessed both the standard ware and the structure of the pottery – 'no-one to be called a student, but [only] younger and older potters'[37] – and gradually decreased the scale of the operations.

Leach died in St Ives in 1979 at the age of ninety-two. The public tributes to him were generous and widespread, *The Times* obituarist comparing his influence to that of Josiah Wedgwood. The private tributes from potters of diverse backgrounds were revealing. Leach was the key factor in many of them becoming potters: his status as the progenitor of the movement was clear.

# 4
# Beyond East and West?

A child may ask when our strange epoch passes,
During a history lesson. 'Please, Sir, what's
An intellectual of the middle classes?
Is he a maker of ceramic pots?'
W.H. Auden, *Letter to Lord Byron*, 1937[1]

Bernard Leach bridges 'two strange epochs'. The first is the epoch of Auden's poem, when making pots was precious and rarified, the occupation of a middle class Bohemian vanguard. Being a potter was a testament of faith. It necessitated having both an apologia and an intellectual argument to justify the strangeness and contrariness of this activity. Leach's life up until the publication of *A Potter's Book* was a struggle to find ways of justifying and articulating what he did. Making pots and making definitions about making pots were intricately linked. His advocacy for being a potter was all the more powerful and heartfelt because of his early life in Japan, of living and working amongst a supportive and interested small group of patrons. In leaving Japan, he also left a way of living as an artist that seemed purposeful. In arriving in a country that was unaware of his talent, Leach's later years at St Ives and Dartington were an attempt to recreate a space in which to live creatively. What in Japan had been private art, making pots for exhibiting to a tightly knit group of friends, eventually became a public art through his career in England. Leach's studio was open to visitors. He demonstrated Raku to the seasonal tourist trade and throwing to the curious at exhibitions and trade fairs. He wrote passionate letters to newspapers and journals, articles for magazines, and published his pamphlet *A Potters Outlook*.

57
Large Jug 1960
Stoneware
H.32.5 cm
Buckinghamshire County
Museum

Other potters of the time did not see themselves as advocates to a greater public in quite this passionate and engaged way. For William Staite Murray, exhibiting his pots in the late 1920s with artists like Christopher Wood and Ben Nicholson, the idea of demonstrating, making the process of art visible, would have been unthinkable and somewhat degrading. Staite Murray's studio was hermetic. As an artist who used clay his conversations were with fellow artists, rather than with an unconnected public. But for Leach, who could not live as an artist as he had done in Japan, making pots and the public role of being a potter began to overlap. And being a potter began to have not only personal vocational significance (following an inner spiritual journey through the respect of materials) but also a public and didactic converting role. Leach became the first modern potter, middle class, a maker of ceramic pots, necessarily an intellectual of sorts. Hence the air of moral regeneration noted at his retrospective.

Pottery between the wars is a rootless art. For some critics pottery could be related to the interest in organic form of key sculptors of the day. That

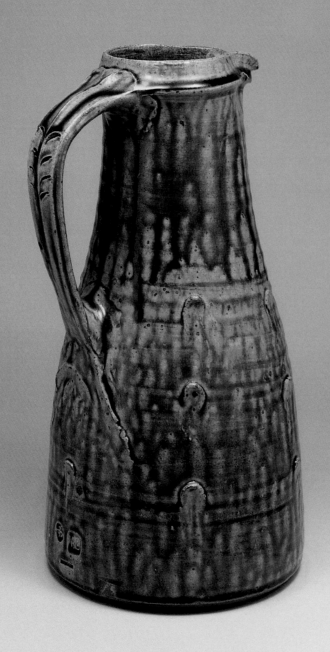

Henry Moore collected medieval jugs, noted the critic Geoffrey Grigson, was indicative of this 'romantic' abstraction: 'what is typically English in pottery seems to me never out of touch with the roundness and solidity of natural forms, the human breast or thigh, the tree trunk, the boulder, the flint block, if you like, the turnip.'[2] Clay was being used in ways that seemed contemporary: the articulation of forms seemed in Patrick Heron's vivid words to be 'submerged rhythms'. 'We feel a powerful pulse in their pots: a rhythm that seems at its most emphatic just below the glazed surface. This is also a characteristic of natural forms – logs; boulders that have been washed by the sea; or even in the human figure, where the structural form is *below* the surface of the flesh – the bone is under the muscle.'[3]

Critics seemed to be interrogating this new phenomenon of studio pottery as to its ambitions. Was it a genuine alternative to industrial ceramic manufacture ('necessary pots')? If so its expense and technical imperfections were manifest problems. Was it a decorative art, a useful resource for 'interior decorators and architects' to employ, (nursery fireplaces, earthenware chargers for country house walls)? Was it an art that was the peer of contemporary painting or sculpture, to be shown in very particular places and ways? Leach is at the heart of this 'strange epoch', attempting new definitions, new ways of selling work, juggling new unequivocal convictions with new equivocations.

Leach was instrumental in defining the canon of pots that potters can draw upon as genuine precursors to this new and hybrid art. His writing established the canon by which his own work was judged. His exclusions (almost all industrially manufactured ceramics, the work of the French pioneer studio potters, any of the highly decorated vernacular English pottery traditions, figurative ceramics in their entirety) remained as startling lacunae in the world of handmade pottery until the late 1950s. But in this epoch, with the canon as yet unossified, Leach's idea of appropriate pots was challenged vigorously. An article by Geoffrey Grigson in the *Studio* of 1935 shows the combative nature of the debate: 'The best modern analogues for the medieval earthenware or the Siamese stoneware bowl of the tenth century, the T'ang earthenware jar, the Chinese stoneware bowls of the twelfth and thirteenth centuries or the Japanese firepot which were included for comparative purposes in the exhibition were not pots by Mr Staite Murray, Mr Bernard Leach, Miss Pleydell-Bouverie or Mr Michael Cardew … but the Doulton fire-clay crucibles, the stoneware ginger-beer bottles, the mercury-bottle and bung-jar shown by Messrs Joseph Bourne.'[4]

Grigson found a 'quality of seemliness and vitality and solid grace' in the work of uninterrupted factory craftsmanship; in porcelain beakers, crucibles, evaporating and crystalising dishes and so on. His ceramic canon, like that of Herbert Read at the same time, is more profoundly demotic than Leach's. As Henry Bergen had said when editing *A Potter's Book*, coming across Leach's romantic apprehensions as to the reach of English country pottery, there was 'nothing more fatuous than to idealise the past except to idealise the present … even what we call country ware was used only by the better-to-do farmers'.[5] Leach is confronted and argued with. His ideas are taken seriously enough to be given the credit of public disagreement.

The second 'strange epoch' is the epoch of Leach's later life, the 1960s and 1970s. By now making pottery was a common recreational pursuit, the stuff of ubiquitous evening classes and craft fairs. The studio pottery movement had

burgeoned; potters filled every margin of the countryside. And there were magazines, associations, galleries devoted entirely to the dissemination of handmade pottery. It had become a 'rooted' art and a profession. As had been foreseen at the Dartington Conference of 1952 'to Leach or not to Leach' had become the driving question within this pottery world. Pottery was a new kind of enclosed group – one to which potters became attached through some sort of empathetic election. It was possible to consider 'orthodoxies' within the movement: covert degrees of adherence to Leach's ideas and precepts, overt rejections of his standpoint. But this was less a debate about the relationship between handmade pots and industry, or indeed pottery and contemporary art and architecture, more an increasingly marginalised conversation between insiders. Leach, a man with students but no peers in the West, received less and less of the robust, unsettling debate that had kept his certainties in check.

In the West, Leach has been seen as 'a natural child of the East',[6] someone who 'understood' Japan by birthright and in an almost mystical way. In the East, he has been credited with seeing deeper into the culture of Japan than any Westerner since Lafcadio Hearn, of being attuned to the country and the people. Yanagi's description is almost religious: 'We were drawn to each other silently and irresistably; I think we realised instinctively that our characters were necessary to each other. From that time on he lived among us as one of us. Our spiritual appetites were the same, we moved about in an unknown world, looking for our real world. Our hope was his hope, and our agony was his agony. He probably got nearer to the heart of modern Japan than the ordinary Japanese did. It is doubtful whether any other visitor from the West ever shared our spiritual life so completely.'[7]

Leach is anointed by Yanagi: Yanagi is anointed by Leach. The rhetoric is hyperbolic and overheated and both these friends see each other as the conduit of spiritual truths, as seers. What is curious is that this friendship has been taken so uncritically, that their mutual gratitude and the ways in which they ascribe authority to each other has not been examined. At the start of their friendship, Leach was a trophy for Yanagi, a young artistic Westerner with a bent for talk of aesthetics and spirituality. For Leach, Yanagi was a way into a salon life to which he aspired but had no access. A close and genuine friendship grew out of their interlocking needs but there was always a pragmatic heart as well. For just as Leach's authority in the West was constructed around the mythic story of his knowledge and insight into Japan, of his apprenticeship into the Kenzan school, of his 'natural' absorbtion into Japanese life, so Yanagi's authority in the West was constructed through Leach's placing of him as not only famous in Japan but amongst the most profound thinkers on Japan.

Stories build up and anecdotes accrete significance over time. Western critics repeated the 'Japanese Potter of St Ives' stories ad infinitum, but the limits of his Japanese world, of his ability to speak, read, or travel independently, of his knowledge of Japanese pottery traditions, have been overlooked. Yanagi's words 'He lived among us as one of us' should be read with a clear knowledge of the 'us': a small, attenuated group of elite, mostly English-speaking, aesthetes. In later travels around Japan Leach is chaperoned by the leaders of the Mingei movement. Leach's Japan is a closely mediated one.

What may seem curious is why Leach's view of Japan should be attractive to Yanagi and other Japanese friends. Why should this characteristic example of Leach's views, when he is writing of the feeling of glazes to the touch, be even acceptable? 'We feel more than a satisfaction through the eyes. Unconsciously our fingers are invited to play over the contours, thereby experiencing pleasure through the most primitive and objective means. Children play with pebbles with a similar awakening of perception, and orientals have lost touch with the fresh wonder of childhood less than we have.'[8] Leach's constant perception of Orientals as child-like, or mystical, or more attuned to the spiritual ('Like unspoilt children no ego intrudes') was a concomitant part of his reading of Oriental pottery as ego-less, mystically alive or, in some nebulous way, spiritual. His discovery of the tactile values of such pottery led him to consider that sense responses were the defining principle, that pots were congeries of feelings. His difficulties with the Kenzan forgeries, where he was involved with urbane, complex, 'ego-full' traditions have been explored earlier, but what emerges clearly is that Japan becomes a symbol for Leach of the mysterious rather than the understood. It is this that appeals so strongly to Yanagi.

In this, of course, Leach partly reflects his age. Leach's Orientalism remains that of an Edwardian art-student brought up on the seductive exoticism and melancholy of Lafcadio Hearn's prose and the unfocused whimsy of Whistler's vision of the East. This kind of Orientalism was a powerful force amongst Leach's Japanese friends. For Yanagi, as an urbane young aristocratic intellectual, his own relationship with rural Japan was similar to that of an ethnographer. Rural potters or weavers, any Korean makers at all, were almost as exotic to him as to Leach.

For many commentators on studio pottery, as well as potters themselves, Leach and Yanagi's vocabulary has been adopted wholesale: 'As is well known, in general terms the East stands for the importance of the inner life over the external, pyschological insight over material forms, the inspiration and generative forces of the artist over the technical triumphs of execution', wrote Wingfield Digby in 1952.[9] East and West are mediated as soul and mind, inner life and external life, instinctive and critical impulse. These great and pleasingly simple polarities, much discussed when Leach and Yanagi were earnest young men stayed with them throughout their lives. Indeed so much energy was invested in exploring the polarity that the suspicion arises that East and West could only be bridged by them. For potters Leach becomes the interlocutor with the East, the key to unlock the arcane world of Oriental pottery. How this pottery became invested with the arcane has been overlooked.

Leach's reputation as a maker of pots has become entwined with that of his followers. 'Leach style' has become a common, and mostly perjorative, referent. It has come to be code for muddy colours, unarticulated forms, indeterminate Oriental-ish brushwork and a certain modesty of ambition. The idea of a possible function for the pot is seen as the overriding determinant. This is a curious anomaly. Leach's 'individual' pots were many and various in their styles: they cannot be stylized in such obvious ways. It is only a reading of Leach's pots that centres on the most standard of his standard wares that leads to this belief. His early Raku pots, his earthenware chargers, his tiles and fireplaces, his enamel-decorated porcelain, his large tenmoku jars, and his late fluted porcelain bowls are all in flight from any idea of a 'standard

58
Bernard Leach's 'Analysis of a Pot' from *The Potters Challenge*, 1975

range' of pots. The endless repetition proscribed by Leach in a revealing image — 'Think of the hours women have spent with knitting needles and in cooking good homemade food. In such they found pleasure and satisfaction as well as work. Repetition for a hand potter is of a like nature[10] — was never his life. He never gained great technical facility in throwing, and never pretended that he had gained it. He never needed to make such a sacrifice of his time. Throughout his life at Abiko, and in Tokyo, in St Ives and in the Japanese pottery villages, pots were thrown under his direction for him to decorate.

In many ceramic traditions, of course, the roles of making and decorating have been distinct. The paradoxes come in Leach's writing. In Leach's rhetoric of the alienated worker, the factory-hand waiting to be liberated after the war into 'real work', the stress was on that of integration: that at this particular moment in history the potter could and indeed should have control over all the processes of creation. This has been the great and powerful seduction of *A Potter's Book*: its sense of self-sufficiency. Leach's relationship with those who worked for him in his studios, those whose 'orchestral playing' he 'conducted', seems to stand in direct opposition to such a rhetoric. The workshop 'craft' ethos that he promulgated was based on the centrality of an artist as a catalyst for those whose creativity was of a lesser kind. His views on the craftsman were never complex, his views on the artist, the decorator of the craftsman's work, the conductor of the studio were considerably more flattering. Decorating, like conducting are more visible roles to adopt.

This is not to suggest that Leach did not repeat patterns. In the standard ware he decorated the majority of the 'marmalade jars' and many of the simple 'zed' bowls, too. In his 'individual' pots he employed the same patterns on pieces widely separated in time: his 'Tree of Life' motif, first used in the 1920s, was still a part of his repetoire in the 1960s. But by both initial training as an art student and by inclination too, Leach was more engaged with the dynamics of mark-making in its widest sense (drawing, engraving, etching, painting, slip-decorating, combed decoration into clay, sgraffito, fluting and so on) than with the dynamics of making forms. His graphic work, etchings in earlier life and pen and wash sketches in later years, fed constantly into his decorations for pots. He initiated ideas in two dimensions, rather than through experimenting on the wheel with alternate forms. Indeed his diagram of how to analyse the form of a pot seems to be not only didactic but of a demonstrably prescriptive bent. The characteristic process for Leach was to

Double termination
Concave
Shoulder
Head or capital
Change at right angles
Hidden cylinder
Top of pattern
Full convexity
Belly hidden sphere
Neutral area
Bottom of pattern
Thrust
Rising power
Wide foot and straight thrust
Breadth and stability
Neutral colour, black, broken by a wave movement in rust red.
A small neck and full body with a wide foot helps the effect of power and dignity.

sketch pots before they were made: making as exploration of form, as a three-dimensional kind of sketching was not part of his life. This may explain why many of Leach's most resolved works are those where he has strongly delineated the forms to frame the decoration. His dishes made when he was driven by enthusiasm for early slipware, his tall 'medieval' jugs or his slab bottle vases all reveal this clearly. These are pots that have 'sides' to them in the most basic of ways: they are by no means complex forms. Less resolved are those pieces where there is a strong sense of a bravura 'exhibition' at work: the famous 'Leaping Salmon' vase, for instance, only has one satisfactory viewpoint but many 'sides'. It is as close to a picture on a pot as is possible. It ought to represent the nadir of the studio pot within Leach's own philosophy. Yet it remained one of his favourite pots.

Leach's greatest strengths as a potter lie elsewhere. His sophistication in 'mark-making' is matched by his sensitivity to the surface qualities of clay. In his very earliest experiments with sgrafitto there is a caution and inhibitedness to the movements that may reflect his sense of the connections between print-making and decoration. Hamada's sgrafitto bowls of the same period are magisterial in their ease by comparison: there is a real sense of incision through the slip into the clay. But with great rapidity Leach builds up a vocabulary of techniques that allow him a more robust interaction with surfaces of pots: his judgement about when to leave parts of pots unglazed to reveal the colour and texture of the fired clay becomes increasingly fine. His use of applied sprigs of clay in the medieval manner, or of combing directly into the clay itself, shows Leach enjoying this stronger connection. His employment of a considerably wider range of glazes than was generally acknowledged is interesting in that, though the tonal range of the glazes is slight, their texture is often a matter of subtle variation. It is as if Leach's actual interest in pots, though iterated as being in the total somatic experience of looking at, touching, handling and using the pot, actually stopped at the surface. This would go some way to explain that whilst the greater part of his rhetorical life was spent in trying to make a space for 'necessary pots' to be appreciated, his pots rarely seem to be an excited or engaged response to the idea or practice of function.

59
Large Jar date?
Stoneware
H.33 cm
Holburne Museum and
Crafts Study Centre, Bath

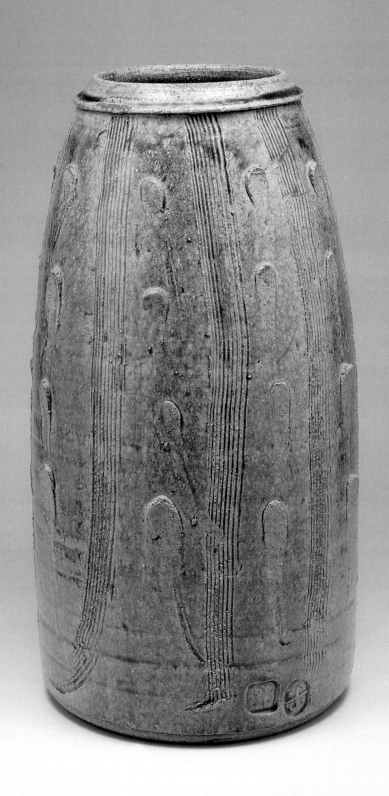

# Notes

BLA Bernard Leach Archive in the Holburne Museum and Crafts Study Centre, Bath

CHAPTER 1

1   Bernard Leach, *Beyond East and West*, 1978, p.23.

2   Joseph Howe, *The Life of Henry Tonks*, 1939, p.40.

3   Bernard Leach, ibid., p.32.

4   Ibid., p.32.

5   Benjamin Disraeli, *Tancred*, 1847, book 2, chapter 14.

6   Bernard Leach, 'The Introduction of Etching into the Japanese Art World' [in Japanese], *Shumi*, June 1909, p.27.

7   See note 1, p.36.

8   Reprinted in Shikiba Ryuzaburo (ed.), *Banado Richi* (Bernard Leach), Tokyo 1934, p.418.

9   Yanagi Soetsu, *Leach in Japan: Collected Works*, vol.21, Tokyo 1989, p.139.

10   Bernard Leach, *A Review*, 1914, p.11.

11   Yanagi Soetsu, ibid., p.64.

12   cf. Ellen P. Conant, 'Leach, Hamada, Yanagi: Myth and Reality', *The Studio Potter*, vol.21, no. 1, Dec. 1992.

13   Ibid.

14   Bernard Leach, ibid., p.12.

15   Yanagi Soetsu, ibid., p.138.

16   Yanagi Soetsu, ibid., p.681, letter of 11 Sept. 1914.

17   cf. Toshio Watanabe, *Japan and Britain: An Aesthetic Dialogue 1850–1930*, 1991, p.166.

18   Bernard Leach, 'Notes on William Blake', *Shirakaba* 5/4, n.d., pp.463–72.

19   See note 1, p.75.

20   Mingei-Kan Library and Archive, Tokyo.

21   See note 1, p.75.

22   See note 10, p.8.

23   Yanagi Soetsu, private notebook, 1915, p.48, Mingei-Kan Archive, Tokyo.

24   E.E. Speight, 'The Drawings of Bernard Leach', *Japan Advertiser*, 6 June 1920.

25   Bernard Leach, *A Potter's Book*, 1940, p.31.

26   See note 1, p.56.

27   cf. Richard I. Wilson, *The Art of Ogata Kenzan*, 1991, pp.182-184

28   Yanagi Soetsu, *Leach in Japan: Collected Works*, vol.14, p.66.

29   Bernard Leach, *A Review*, 1914, p.13.

30   Bernard Leach, 'Notes on William Blake', *Shirakaba* 5/4, n.d., pp.462–72.

31   Bernard Leach to Yanagi Soetsu, letter of 1 June 1914.

32   Yanagi Soetsu, ibid., vol.21, p.681, 1 June 1914.

33   Ibid., p.674, 22 July 1915.

34   Bernard Leach, Introduction to *A Review*, 1914.

35   Yanagi Soetsu, ibid., vol.21, p.655, 23 Oct. 1916.

36   This sketch is in the collection of the Mingei Kan Archive.

37   J.W. Robertson Scott, *The Foundations of Japan*, 1922, p.98.

38   E.E. Speight to Leach, ms letter 2327–2328, Bernard Leach (BL) Archive, 19 April 1919.

39   Yanagi Soetsu, ibid., vol.21, p.643, 6 August 1919.

40   Bernard Leach, *Hamada, Potter*, 1975, p.100.

41   'Democracy in Art', *The Japan Advertiser*, 22 June 1919, p.6.

42   'The Problem of Art in Japan', *The Japan Advertiser*, 22 June 1919.

43   Tsujimoto Isamu (ed.), *Tomimoto Kenkichi, Collected Works* 1981, p.423, section trans. Dr. Chiaki Ajioka.

44   'Democracy in Art', ibid.

45   Bernard Leach, *Beyond East and West*, 1955, p.119.

46   Bernard Leach, *Hamada, Potter*, 1975, p.96.

47   See note 45, p.125.

48   'Democracy in Art', ibid.

49   cf. Yuko Kikuchi, *Ruskin in Japan*, exh. cat., Ruskin Gallery, Sheffield 1997.

50   Bernard Leach, *Living Art in Japan*, March 1919.

51   'Ten Years in Japan', transcription of stenographed notes of Leach's lecture in Japanese, 'The Baron Iwamura's Third Memorial Lecture on Art', 17 March 1920, p.2.

52   See note 46, p.106.

53   Bernard Leach, *Beyond East and West*, pp.118–19.

54   'Bernard Leach's Show Attracts Many Visitors', *The Japan Advertiser*, 4 June 1920.

55   Bernard Leach, ibid., p.134.

56   *The Japan Advertiser*, 4 June 1920.

CHAPTER 2

1   BLA 1381 1921, MS marginalia in *Catalogue of Friday Club Exhibition*.

2   Bernard Leach, *Hamada: Potter*, 1990, p.133.

3   Michael Cardew, *A Pioneer Potter*, 1988, p.28.

4   Bernard Leach quoted in *St Ives Times*, 17 August 1923.

5   Bernard Leach MS autographed letter to Yanagi Soetsu, 27 June 1924.

6   BLA 514, MS of Bernard Leach, *Raku Book*.

7   *St Ives Times*, 17 August 1923.

8   *Evening Standard*, 24 April 1923.

9   *The Times*, 1 November 1923.

10   Michael Cardew, 'The Pottery of Mr Bernard Leach', *The Studio*, 14 November 1925.

11   Bernard Leach, *A Potter's Outlook*, 1928.

12   *The Times*, 23 November 1925, review of 'The Guild of Potters'.

13   *The Studio*, July 1927, p.54.

14   BLA 3181, Henry Bergen ALS 7/8/37.

15   cf. Oliver Watson, *British Studio Pottery*, 1990, p.18.

16   Yanagi, *Collected Letters*, 7 March–5 May 1923, p.622.

17   Letter to Yanagi Soetsu, 4 October 1924.

18   Yanagi, *Collected Letters*, 2 November 1925, p.613.

19   BLA 514, MS of Bernard Leach, *Raku Book*.

20   Letter to Yanagi Soetsu, 6 February 1929.

21   Katherin Pleydell Bouverie, letter to Bernard Leach, 15 August 1928 in Katherin Pleydell Bouverie, *A Potter's Life 1895-1985*, 1986.

22   Harry Trethowan in *Studio Year Book of Decorative Arts*, 1929.

23   Bernard Leach letter to Yanagi Soetsu, 27 June 1924.

24   *Sunday Worker*, 25 April 1926.

25   *The Studio*, March 1927, p.200.

26   'Modern Potters', *The Observer*, 16 December 1928.

27   'Mr Bernard Leach', *The Times*, 6 December 1928.

28   Herbert Read, 'Art and Decoration', *The Listener*, 7 May 1930, p.805.

29   BLA 2007, *Leach Pottery*

*Stoneware Tiles and Fireplaces*, catalogue of tiles, c.1929.

30 *Western Morning News*, 3 March 1934.

31 Bernard Leach *A Potter's Outlook: Handworker's Pamphlets No.3*, 1928.

32 Bernard Leach, circular letter to Japanese friends, January 1928.

33 'Bernard Leach: Pottery' in John Farleigh (ed.), *Fifteen Craftsmen and Their Crafts*, 1945, p.45–6.

34 Margot Coatts, *A Weaver's Life: Ethel Mairet 1872-1953*, 1983, p.60.

35 Bernard Leach, *A Potters Book*, p.11.

36 BLA 2597, Harry Davis to Bernard Leach, 19 April 1935.

37 BLA 5832, Leonard Elmhirst to Bernard Leach, MS 4 December 1931.

38 Tanya Harrod, *Dartington and the Crafts* in *Dartington: Sixty Years of Pottery 1933-1993*, Dartington 1993, p.20.

39 BLA 5870, 21 January 1933.

40 BLA 2542, 20 December 1933, Bernard Leach to Mrs K. Starr, Dartington Research Grants Board.

41 BLA 5932, Leonard Elmhirst to Bernard Leach, n.d.

42 Bernard Leach to Leonard Elmhirst, 4 December 1934. General Correspondence 1926–9, Elmhirst Centre Archive, Dartington Hall.

43 BLA 5935, 25 August 1935, Dr W.K. Slater to Bernard Leach.

44 *Kogei* (Crafts), 1935, no.49, pp.19–20.

45 *Kogei* (Crafts), 1935, no.49, p.26.

46 BLA 5952, 24 August 1934, Bernard Leach to Leonard Elmhirst.

47 *Kogei*, p.16.

48 Bernard Leach, *Beyond East and West*, 1985, p.177.

49 BLA 2407, Henry Bergen to Bernard Leach, 14 February 1935.

50 Bernard Leach, ibid., p.200.

51 Ibid.

52 *Kogei*, p.37.

53 BLA 5952, 24 August 1934, Bernard Leach to Leonard Elmhirst.

54 BLA 5954, 15 January 1935, Leonard Elmhirst to Bernard Leach.

55 BLA 3185, 3 September 1937, Henry Bergen to Bernard Leach.

56 Bernard Leach, *A Potter's Book*, 1940, p.5.

57 Ibid., p.25.

58 Ibid., p.196.

59 *Burlington Magazine*, November 1941, p.169–70.

60 *Times Literary Supplement*, 6 July 1940.

61 *The Listener*, 8 August 1940.

62 Herbert Read in the *New English Weekly*, 11 July 1940, p.144.

CHAPTER 3

1 Bernard Leach, *Beyond East and West*, 1985, pp.221–2.

2 Jeremy Myerson, *Gordon Russell Designer of Furniture*, Design Council 1992, p.85.

3 John Farleigh (ed.), *Fifteen Craftsmen and their Crafts*, 1945, p45–6.

4 Bernard Leach, 'American Impressions', *Craft Horizons*, USA, Winter 1950, p.19.

5 See note 1, p.222.

6 'Bernard Leach: Pottery' in John Farleigh (ed.), *Fifteen Craftsmen and Their Crafts*, 1945, p.44.

7 James Noel White in 'The Unexpected Phoenix', *Craft History One*.

8 *Journal of the Royal Society of Arts*, 21 May 1948, p.366.

9 George Wingfield Digby, *The Work of the Modern Potter in England*, 1952, p.40.

10 Bernard Leach, *A Potter's Portfolio*, 1951, p.24.

11 Leonard Elmhirst quoted in *Dartington Conference: The Report*, typescript 1954.

12 Ibid., p.6.

13 Bernard Leach: *The Contemporary Potter*, p.12, typescript.

14 Robert Melville, *Architectural Review*, vol.112, November 1952, p.344.

15 See note 4, p.18.

16 Ibid.

17 'Potters Dissent: An Open Letter to Bernard Leach from Marguerite Wildenhain', *Craft Horizons*, USA, May 1953, pp.43–4.

18 'An Open Letter from Henry Bollman', *Ceramics Monthly*, March 1953.

19 Jack Laird, 'A Review of the Third New Zealand Potters Exhibition', *New Zealand Potter*, December 1959.

20 Bernard Leach, *A Potter in Japan*, 1960, p.47.

21 Ibid., p.89.

22 Ibid., p.85.

23 Ibid., p.206.

24 Ibid., pp.214–15.

25 Ibid., p.206.

26 Ibid., p.203.

27 Ibid., p.102.

28 Ibid., p.147.

29 Bernard Leach, *Kenzan and his Tradition*, 1966, p.28.

30 Ibid., p.108.

31 BLA 4859 BL6TK, 9 September 1962.

32 Margaret Medley, 'Clay in Their Hands: Review of Shoji Hamada', *Times Literary Supplement*, 24 December 1976, p.1612.

33 Bernard Leach, *Drawings, Verse and Belief*, 1973, p.6.

34 Francis King, 'The Sincerity of the Potter', *Times Literary Supplement*, 26 May 1978, p.582.

35 Bernard Leach, *The Potters Challenge*, 1975, p.134.

36 John Spurling, 'Sermons in Stone', *New Statesman*, 18 March 1977.

37 Janet Leach, *Ceramic Review*, July–August 1979, p.20.

CHAPTER 4

1 W.H. Auden and Louis Macniece, *Letters from Iceland*, 1937, p.201.

2 Geoffrey Grigson, 'In search of English Pottery', *The Studio*, November 1935, pp.256–63. See also Bernard Leach, 'A Potter's Reply', *The Studio*, February 1936, p.119.

3 Patrick Heron, 'Submerged Rhythm', *The Changing Forms of Art*, 1962, p.64.

4 Grigson, ibid.

5 BLA 3181, Henry Bergen to Bernard Leach, 7 July 1937.

6 Edwin Mullins, 'Leach as Author' in Carol Hogben (ed.), *The Art of Bernard Leach*, 1978.

7 Yanagi in Bernard Leach, *A Potter's Book*, 1940, p.xiv.

8 Bernard Leach, *A Potter's Book*, p.37.

9 George Wingfield Digby, *The Work of the Modern Potter in England*, 1952, pp.25–6.

10 Bernard Leach, *The Potter's Challenge*, 1975, p.19.

# Select Bibliography

CARDEW, Michael, 'The Pottery of Mr Bernard Leach', *The Studio*, 14 Nov. 1925.

GRIGSON, Geoffrey, 'In Search of English Pottery', *The Studio*, Nov. 1935.

HARROD, Tanya, *Dartington and the Crafts* in *Dartington: Sixty Years of Pottery 1933–1993*, Dartington 1993.

HERON, Patrick, *'Submerged Rhythm': The Changing Forms of Art*, London 1955.

KIKUCHI, Yuko, 'The Myth of Yanagi's Originality: The Formation of Mingei Theory in its Social and Historical Context', *Journal of Design History*, vol.7, no.4, 1994.

LEACH, Bernard, *A Review, 1909–14*, Tokyo 1914.

LEACH, Bernard, *An English Artist in Japan*, Tokyo 1920.

LEACH, Bernard, *A Potter's Outlook*, Handworkers' Pamphlet no.3, New Handworkers' Gallery 1928.

LEACH, Bernard, *A Potter's Book*, London 1940.

LEACH, Bernard in John Farleigh (ed.), *Pottery: Fifteen Craftsmen on their Crafts*, London 1945, pp.44–52.

LEACH, Bernard, 'American Impressions', *Craft Horizons*, Winter 1950.

LEACH, Bernard, *A Potter's Portfolio: a Selection of Fine Pots*, London 1951.

LEACH, Bernard, *Kenzan and his Tradition*, London 1966.

LEACH, Bernard, *Hamada Potter*, Kodansha 1975.

LEACH, Bernard, *Drawings, Verse and Belief*, London 1977.

LEACH, Bernard, *Beyond East and West*, London 1978.

WINGFIELD DIGBY, George, *The Work of the Modern Potter in England*, London 1952.

LEACH, Janet, 'Fifty-one Years of the Leach Pottery', *Ceramic Review*, March–April 1972.

MOERAN, Brian, 'Bernard Leach and the Japanese Folkcraft Movement: the Formative Years', *Journal of Design History*, vol.2, nos.2 and 3, pp.139–44.

READ, Herbert, 'The True Philosophy of Art', *The New English Weekly*, 11 July 1940, pp.143–4.

DE WAAL, Edmund, 'Homo Orientalis: Bernard Leach and the Image of the Japanese Craftsman', *Journal of Design History*, vol.10, no.4, 1977.

DE WAAL, Edmund, 'Beyond the Potter's Wheel: The Furniture of Bernard Leach', *Crafts*, no.129, July–August 1994.

WATSON, Oliver, *Bernard Leach*, Crafts Council, London 1977.

WATSON, Oliver, *British Studio Pottery*, London 1990.

WILSON, Richard, *The Art of Ogata Kenzan*, New York 1991.

YANAGI, Soetsu in Bernard Leach (ed.), *The Unknown Craftsman*, Kodansha 1972.

# Photographic Credits

# Index